IMAGES
of America
PACIFICA

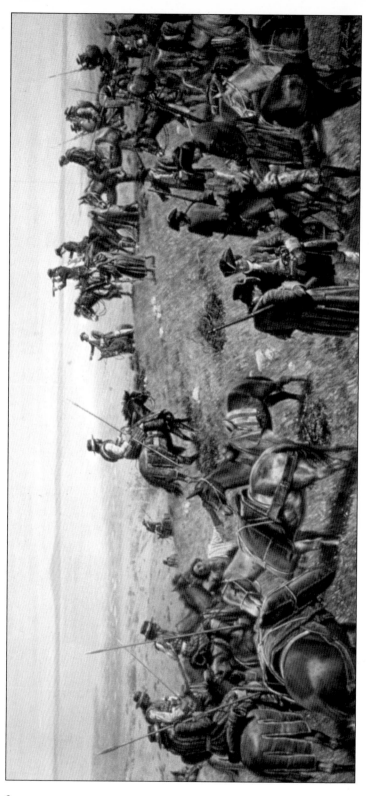

Cover photo: A young lady and a young village by the sea. In what is now Pacifica in the mid-1920s, an unknown photographer deftly caught history and excitement. The unidentified girl is standing next to Sharp Park's Castle. Landmarks directly behind her include the Little Brown Church through the trees and San Pedro school (now City Hall), barely visible. The two-story building on the left is at the corner of Old County Road (now Palmetto Avenue) and Salada Avenue; it was the Salada Hotel. The County Road Market is at far right.

This famous painting memorializes the November 4, 1769 "discovery" of the San Francisco Bay by Spanish explorer Gaspar de Portolá as it was imagined by renowned painter Morton Kunstler. The mountaintop, now known as Sweeney Ridge, is south of San Francisco and sits within Pacifica's city limits. It is a part of the Golden Gate Recreation Area. (From the original painting by Morton Künstler, *Portolá Discovers San Francisco Bay* © 1970 Morton Künstler, Inc.)

IMAGES
of America

PACIFICA

Chris Hunter, Bill Drake,
and the Pacifica Historical Society

ARCADIA

First Printed 2002
Reprinted 2003, 2004, 2005

Published by Arcadia Publishing
Charleston SC, Chicago IL, Portsmouth NH, San Francisco, CA

Printed in Great Britain

Library of Congress Catalog Card Number: 2003102228

For all general information contact Arcadia Publishing at:
Telephone 843-853-2070
Fax 843-853-0044
E-Mail sales@arcadiapublishing.com

For customer service and orders:
Toll-Free 1-888-313-2665

Visit us on the internet at http://www.arcadiapublishing.com

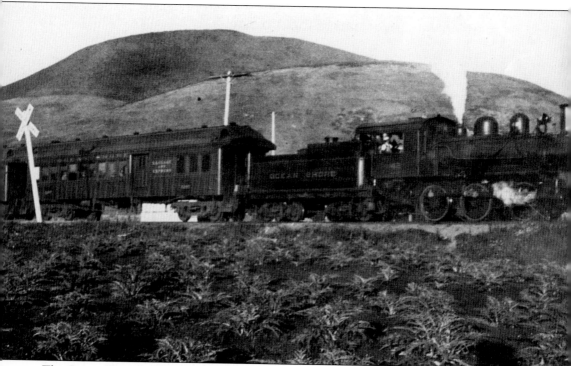

The Ocean Shore Railroad, one of the unique historical aspects of Pacifica and the San Mateo County coastside, rolls through Rockaway Beach in the second decade of the 20th century. Cattle Hill, now part of the Golden Gate National Recreation Area, is in the background.

CONTENTS

ACKNOWLEDGMENTS

Publishing this book would have been impossible without the unstinting cooperation of the *Pacifica Tribune* and the Pacifica Historical Society, and the generosity of many individuals, past and present. Many of the photos were the work of the late Lloyd Easterby. Other photographers whose skills are well-represented include Bruce Walker, Donna Starr, Horace Hinshaw, Bill Drake, Lee Forster, and the late Lotus Perez. There are also photos and artwork in this book from the collections of Grace McCarthy, Penny and Dick Keating, Helen James, Laguna Salada Union School District, Jerry Crow, San Mateo County Historical Association, Robert Siebert and Ray Higgins, Connie and Mason Brown, Joe Fulford, Charlise Heiser, and the MacDonald Historical Collection (from the first decade of the 20th century). Other photographers represented include Mary Beauvais, Alice Blankfort, Beverly Ramsay, members of the Bouly family, Robert Bradford, Patti Campillo, the Gay family, John Griffith, Tom Jackson, Russ Kelley, and John and Margaret Risinger. A special thanks to artist Morton Künstler for permission to reproduce his well-known painting of Portolá's discovery of San Francisco Bay. The book committee would very much appreciate the names of any photographers represented in this collection who may have been overlooked inadvertently.

CITY of PACIFICA · INCORPORATED · NOV. 22, 1957

INTRODUCTION

Though tens of thousands of people are, or have been, Pacificans in the past half century or so, in some ways they're a lot like a family. We Pacificans share a lot of common experiences. Also like some families, we tend to argue a lot. Even some family tragedies, storms, fires, floods, oil spills, and mudslides have brought us closer together. One reason for incorporating Pacifica was to maintain a kind of "us against the world" mentality, intended to keep out undesirable intrusions such as garbage dumps. When *Pacifica Tribune* staffers and Pacifica Historical Society members got together to create this book, it turned out to be a lot like a family album. Like all such compilations, it is a bit skewed by the material that's available. Pacifica's early history is a bit sparse. The *Tribune* wasn't around to photograph the many details of the lives of Portolá and Sanchez and their families. The Ocean Shore Railway era is better covered in Jack Wagner's book *The Last Whistle*. Another irretrievable loss resulted from the inadvertent corrosive

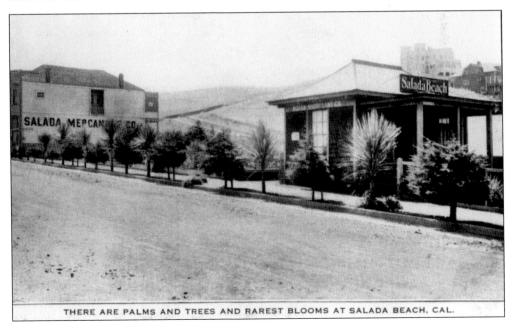

THERE ARE PALMS AND TREES AND RAREST BLOOMS AT SALADA BEACH, CAL.

destruction of certain *Tribune* photo files from the 1950s and '60s. Pacifica has been made unique by its geology, its history, and the distinctive mix of people who have lived here. Its name and its symbol were borrowed from an 80-foot statue originally intended to be only an ephemeral part of an International Exposition celebrating peace and international amity, which took place just before one of the bloodiest wars in world history. Pacifica brought together a number of older rural communities and postwar tract developments. Throughout its history (recorded first in 1769), the seaside now known as Pacifica never had a crossroad to build a city around. This book of images is intended to provide an overview of Pacifica. It is not a thorough compendium of every aspect of life on the Coastside. It has plenty to offer, but we must apologize for all that is left out. There are a lot more details for future books about Pacifica. The Pacificans who've put together this collection, including Bill Drake, Chris Hunter, Jerry Crow, Helen James, and Paul and Lydia Azevedo, hope you enjoy it. If you have photos you feel should have been a part of this book, why not share them? Your contributions may become a part of a Pacifica album in the future. We appreciate the generosity of everyone who has shared photos with us. Thanks. Contact the Pacifica Historical Society at P.O. Box 752, Pacifica, California, 94044.

The Discovery of San Francisco Bay

Long before Pacifica was born, the unique geography of the San Francisco Bay Area had already established the region as one of great significance. For many years, its mountainous coast and rocky beaches hid the magnificent Bay itself from sailors, until a fateful day in 1769. This portrait of Gaspar de Portolá, the first governor of Alta and Baja California, shows the man who led the expedition intended to find Monterey Bay by a land route. When he and his 63 men came to the coast at the mouth of the Salinas River, the area looked so little like the Monterey Bay they expected to find that they continued traveling north. By the time they camped out in San Pedro Valley, the sightings of Point Reyes and the Farallone Islands provided convincing evidence that they had come too far. Climbing east to the top of Sweeney Ridge, they "discovered" the great inland bay that would one day be ringed with seven million people. In one sense, San Francisco Bay was a sign of failure. Portolá had failed in his mission. But for 200 years, Spanish ships had made landfall at Cape Mendocino and sailed south to Acapulco, and no one had ever discovered that there was a body of protected water sufficient to float all the navies of Europe. Portolá's discovery was one of the most successful "failures" in the history of human exploration.

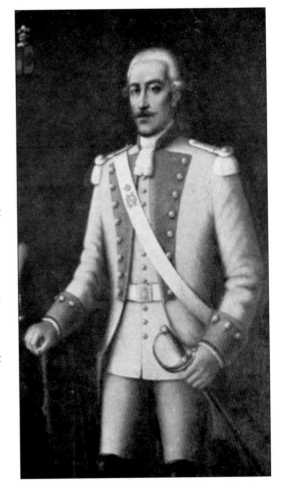

This view of the San Francisco Bay from Sweeney Ridge greeted Portolá in 1769. It still greets anyone who hikes to the top of the ridge, which is now part of the Golden Gate Recreation Area. Entrances to the park are in Pacifica and San Bruno.

Gaspar de Portolá's hometown of Balaguer, Spain, is the official Sister City of Pacifica. Portolá is an honored hero in both communities. Balaguer, a medieval river town in the region of Catalonia, is much older than Pacifica. Through the years, there have been numerous exchange visits by citizens of both cities.

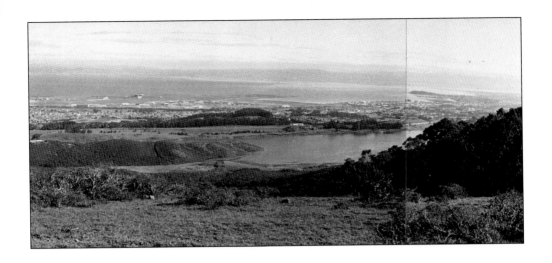

When the Discovery Site on Sweeney Ridge was dedicated as a National Historical Landmark in 1972, a bronze plaque on a stone monument was placed there with the inscription: "From this ridge the Portolá Expedition discovered San Francisco Bay November 4, 1769."

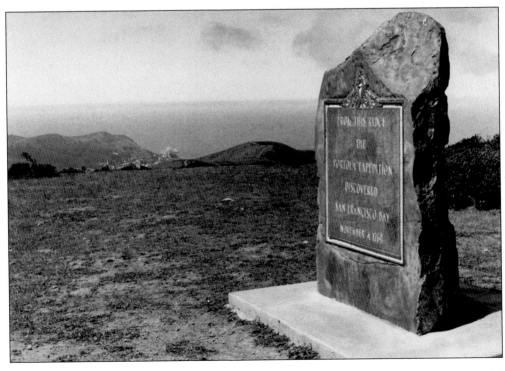

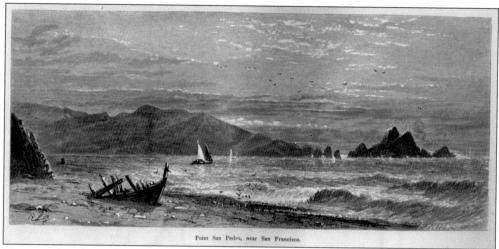

Point San Pedro, near San Francisco.

The rugged outline of Point San Pedro, and especially San Pedro Rock, has changed little since 1894 when this lithograph (above) was published as part of something called the Educational Art Series. Subscriptions to the weekly series cost $5 a year, a significant sum for families who earned $1 a day or less. The 1877 Official San Mateo County map shows that Point San Pedro was one of the few prominent features named along this part of the coast. It was also one of the first navigation references used by the early explorers, having been noted on a chart by explorer Sebastian Rodriguez Cermeno in 1595. The dramatic photo below appeared in the *San Francisco Call* newspaper in 1908, advertising property in "San Pedro Terrace."

Gaspar de Portolá, first governor of Baja and Alta California, was born in the city of Balaguer, part of the region known as Catalonia (Catalunya in the Catalan language) in northeastern Spain. When, in 1988, the government of Catalonia gave this bronze statue of Portolá to the state of California, it was placed in Pacifica, to honor the area where Portolá's expedition culminated in the epochal European discovery of the San Francisco Bay. A creation by the sculptor Subirachs, the statue faces east toward the Discovery Site from Plaça de Catalunya at Cabrillo Highway and Crespi Drive. A local reenactment of the expedition, pictured below, lacks mules, and, therefore, historical accuracy.

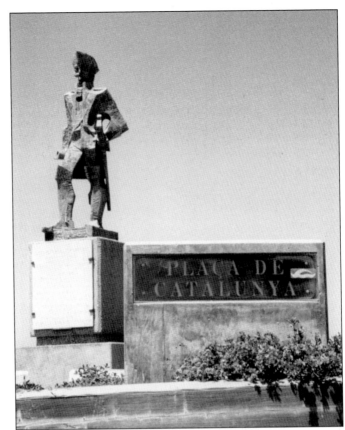

Carl McCarthy, left, was the first person to put together the words "scenic" and "Pacifica," an idea that became the city's slogan. He was persistent in the related campaign to establish the view from Sweeney Ridge as Pacifica's biggest asset, escorting thousands of visitors to the Portolá Discovery Site. He helped focus attention on the history and geography of the ridge, now a national park, but did not succeed in his endless effort to restore the "path of Portolá." He had intended to establish auto access from Pacifica, but could not because of a Golden Gate National Recreation Area no-road policy.

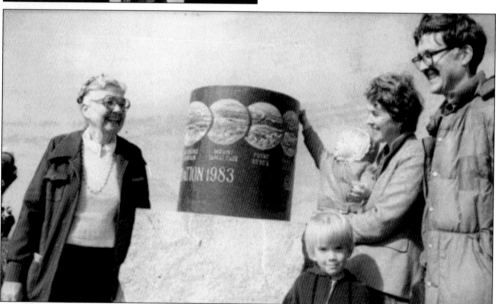

On behalf of the Portolá Expedition Foundation, Mr. Elio Fontana, a Colma monument maker, installed a black granite stele in honor of Carl McCarthy's many years of effort to make the Discovery Site a national historic landmark. The stele has engraved views of eight prominent geographic features to help orient visitors to significant landmarks visible from the site. Pictured above is Carl's wife Grace McCarthy, with family members, at the monument. The inscription reads: "In memory of Carl Patrick McCarthy whose dedicated efforts for national recognition of the Portola expedition's discovery of San Francisco Bay in 1769 included personally bringing 11,863 visitors to this Discovery Site and presenting the expedition's history in pictures to 9,345 between 1956 and his death October 15, 1981."

14

Two

OHLONE INDIANS, SPANISH MISSIONS, AND A CASTLE

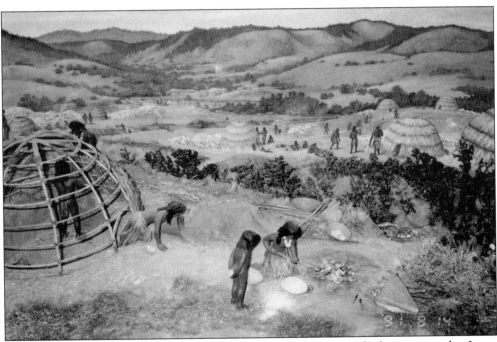

The site of the village where Portola first made local contact, Pruristac, looks inviting today. It was on the north bank of San Pedro Creek behind where the Sanchez Adobe now sits. The journals of the explorers referred to a population of "six or seven families" in this village. The Ohlones in this area made huts of tules tied over willow branch frames, as shown in the photograph of an exhibit at the San Mateo County Historical Museum in Redwood City. The Ohlones were expert at working with wood, reeds, roots, animal skins, stone, and obsidian (volcanic glass). Their baskets were so expertly woven that water could be kept, and even boiled, in them.

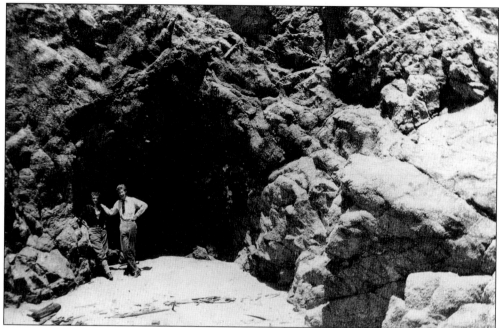

When the Spanish explorers arrived, one of the things they noticed was that the Ohlones were extracting lime from a small cave, such as this one, on the site that later became the Rockaway Quarry. The Indians made use of the mineral for body paint. Subsequently, the Spanish enlarged the diggings to provide whitewash for the mission and presidio buildings from San Francisco to San Jose from 1780 to 1782.

The only other village in Pacifica evident to the explorers was Timigtac, near what is now the intersection of Reina Del Mar Avenue and Highway 1. There were no other villages along the coast from here to the Golden Gate because the soil was very sandy and the winds blew strongly much of the time. The explorers said that perhaps only one extended family lived on this site. A substantial shell mound, or midden, is on the site, an indication that quantities of clams and mussels were consumed there over a period of many years. It may have been used mainly for periodic gathering of seafood, much as a hunting lodge is used.

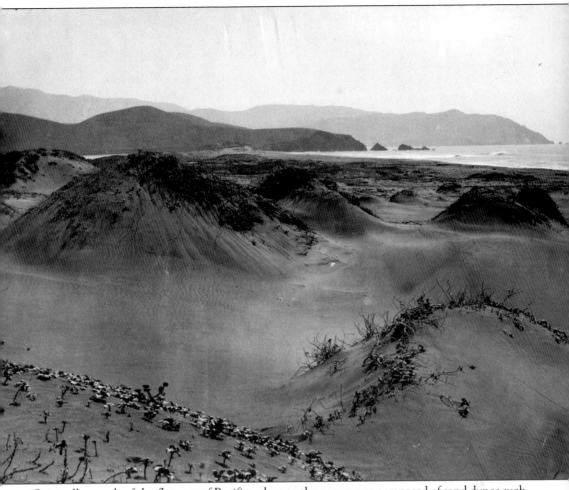

Originally, much of the flat part of Pacifica close to the ocean was composed of sand dunes such as the ones in this *c.* 1900 picture. In *John Barleycorn*, Jack London referred to "the bleak sad coast of San Mateo County south of San Francisco. It was a wild, primitive countryside in those days(1883)." He also described visiting a neighboring ranch "down the long bleak road among the sandhills" between their farm, in what is now Pacific Manor, and a ranch around Rockaway. The present landscape of gardens, parks, and trees contrasts favorably with the early conditions. Local children walked or rode up these hills to the original San Pedro School, located near what is now the intersection of Hickey Boulevard and Skyline Boulevard. Due to increased population along the coast, the San Pedro School District was formed out of the San Bruno School District in 1869. When the school burned down in 1893, the second San Pedro School was built near the intersection of Highway 1 and Mori Point Road. "Schoolhouse Cut" is the pass through Mori Ridge that now connects Fairway Park District with Vallemar.

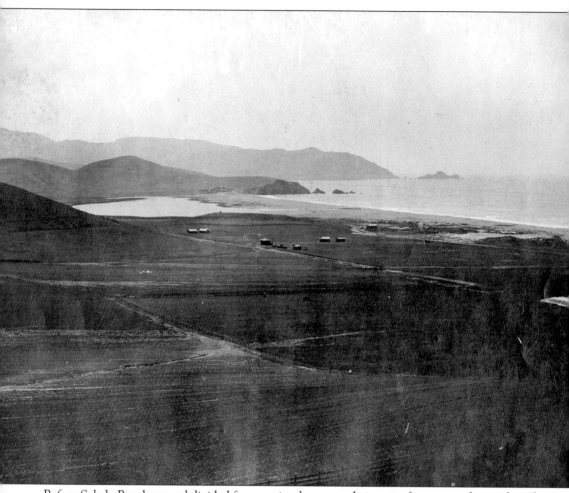

Before Salada Beach was subdivided for vacation homes and given its first name, the sandy soil was found suitable for artichokes. This eminently edible thistle was imported by early Italian farmers in the area, and a flourishing crop developed. At one time, 90 percent of the artichokes consumed in the U.S. grew on farms along the coast of San Mateo County. As development replaced local farm acreage with neighborhoods, the center of artichoke farming moved south to Monterey County.

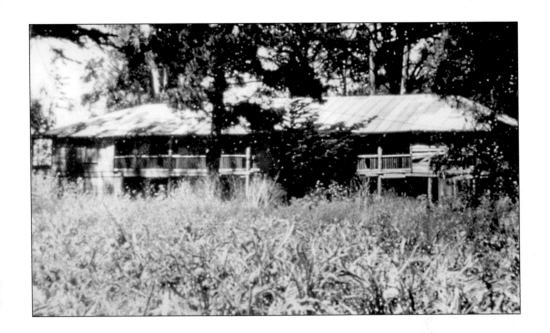

The Sanchez Adobe was constructed in its present general form in 1842–46 using timbers salvaged from a Spanish vessel that had been wrecked on Point San Pedro. Rancho San Pedro was granted to Francisco Sanchez in 1839. This painting with the wagon is of the Sanchez Adobe in about 1920, and represents one of its livelier periods. A place of liquid refreshment and entertainment, each night a new group of girls was brought down from San Francisco in a wagon like that in the picture.

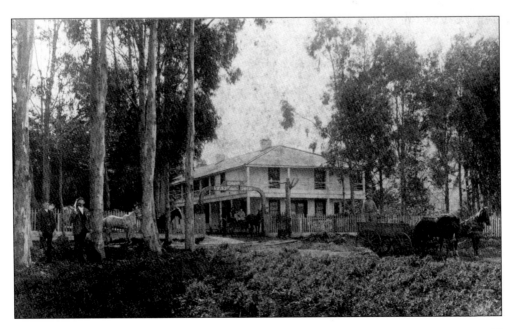

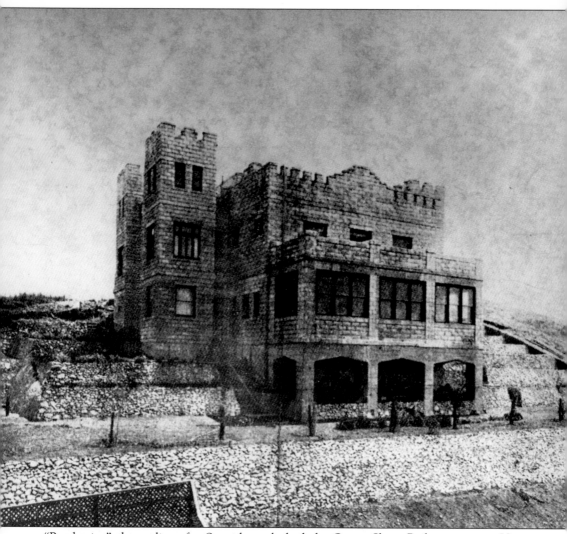

"Bendemier," the replica of a Scottish castle built by Ocean Shore Railway attorney Henry Harrison McCloskey in 1908, is pictured as it looked before the surrounding trees grew up. McCloskey wanted a sturdy home to provide a safe haven after his San Francisco home was severely damaged by the 1906 earthquake. The exterior "stone" is actually made from 90-pound concrete blocks made to look like stone. Math Anderson, local carpenter and owner of Anderson's Store, did much of the interior detail work. It was sold by the family after Henry's death in 1914.

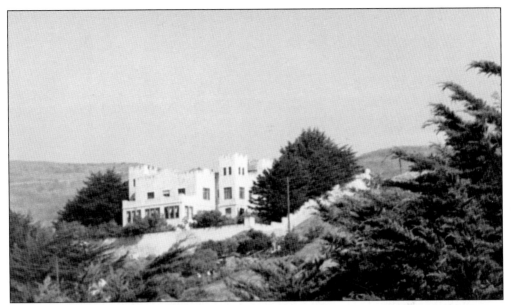

Here is the castle as it looks today.

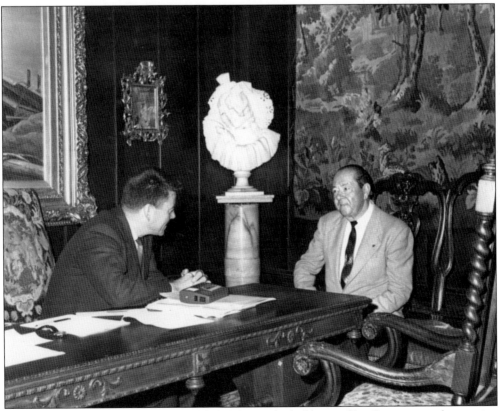

Pete McCloskey, grandson of the builder of the castle, held one of his Congressional campaign events there. The beautifully carved table and other rich appointments that grace the castle interior can be seen in this photograph.

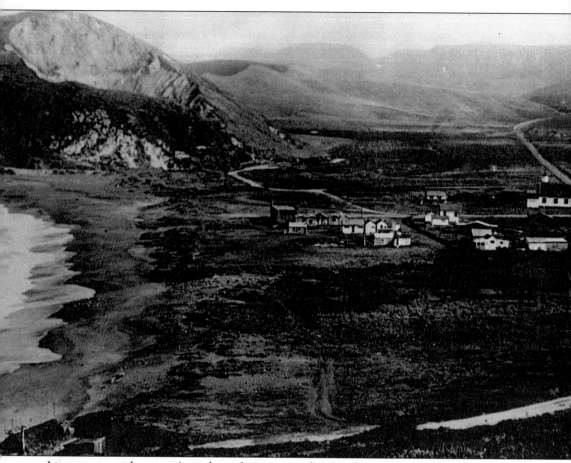

Limestone was the quarry's product of interest until 1904 when Horace Hill of the E.B. & A.L. Stone Company (later Rhodes-Jamieson) bought the quarry and began digging and crushing rock for construction purposes in 1908. He also set up a dragline dredging operation on Mori Point to bring sand from the ocean bottom up to the flat on the bluff. Few regulations existed for blasting activities a century ago, so quarry operators were not always respectful of the comfort and safety of the neighbors. Blasting was usually done without warning, and such large charges were used that stray rocks were known to land in nearby yards. Some houses developed cracks from the blasting shocks. By the 1940s, operations accelerated to aid in the massive construction boom associated with WWII. Demand for sand and rock continued during the post-war housing boom. The particular mix of limestone and granite (87 percent and 13 percent respectively) that came out of the quarry happened to be ideal for "chicken grit," an aid to digestion for those useful birds. For about a year, some of the rock was ground and bagged for shipment to buyers in the Hawaiian Islands who didn't have a good local source of grit for their poultry. The handling and transportation expenses proved to be too high for a profitable operation, so that quaint part of the business soon ceased. Overall demand diminished by the 1960s, and extraction operations ceased in the next decade. The current owner, Bill Bottoms, bought the property in the 1980s, but has yet to develop it. He sold part of it to the City of Pacifica for the new wastewater treatment plant. At that time, the city cleared and graded the gently sloping acres east of the quarry itself as well as the treatment plant site. With the aid of a huge volunteer effort to replant the banks of the formerly despoiled waterway, the city also did extensive reclamation work on Calera Creek. The remainder of the quarry is still considered a viable location for redevelopment.

Three

EARLY DAYS AND A
RAILROAD DREAM

ARTICHOKES, TOURISM, AND THE
OCEAN SHORE RAILROAD

This picture, taken c. 1950 by Robert Bradford, looks southward toward Montara Mountain from what became Alma Heights. Artichokes and San Pedro Creek are in the foreground. These fertile fields also produced crops of peas, potatoes, onions, row crops, heather, lavender, and other flowers. The area looked pretty much the same for generations.

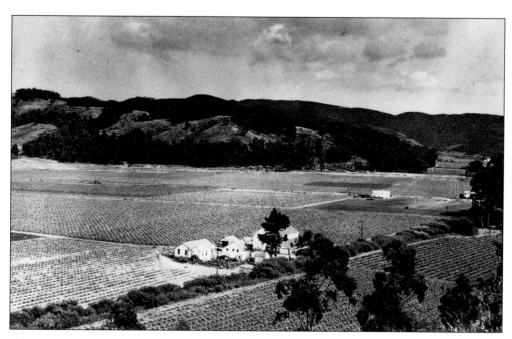

For about three generations, San Pedro Valley was divided into several farms and ranches. The principal crop was the artichoke, but there was also a large pea farm near Alma Heights Academy and potatoes, onions, and row crops were grown in the area. The growers were mostly Italian immigrants. This photo looks east toward what today is Alma Heights Academy. The home in the middle distance may be on present-day Peralta Drive. This pastoral scene ended abruptly in the spring of 1953 when seven of the local ranches were bought up in one weekend—destined to become the group of subdivisions known as Linda Mar.

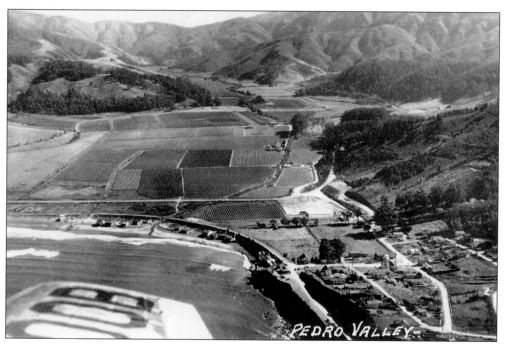

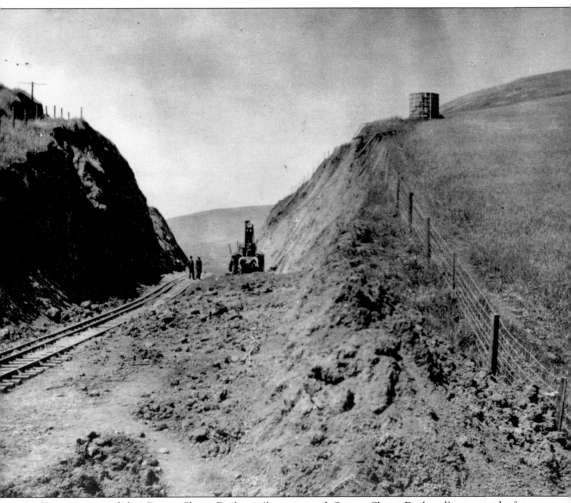

Construction of the Ocean Shore Railway (later named Ocean Shore Railroad) consisted of a combination of easy flat stretches and extremely difficult segments, like the work done on the schoolhouse cut, pictured here. It was given this name because the San Pedro School then sat at the north end of the cut near the intersection of County Road and Mori Point Road. The school was built there after the original San Pedro School, near the present intersection of Hickey Boulevard and Skyline Boulevard, burned down in the late 1800s. The steam shovel shown was indeed powered by a steam engine. The term is still used even though diesel engines now are used.

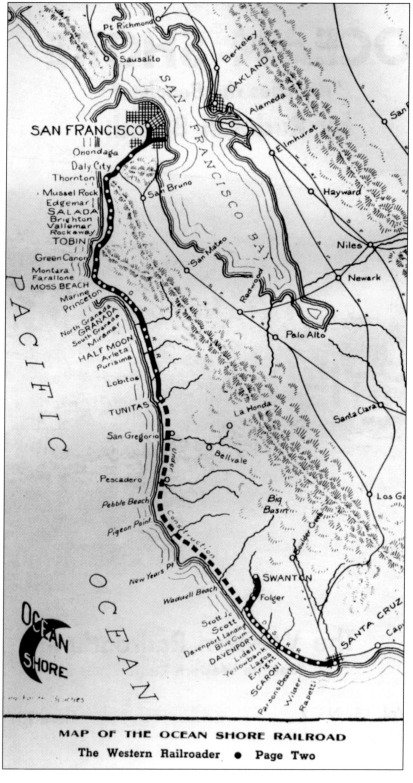

Construction of the Ocean Shore Railway began at both ends, progressing south from San Francisco and north from Santa Cruz. Construction at the Santa Cruz end was impeded when the Southern Pacific Railroad deliberately built a spur across part of the OSRR right-of-way. Despite the many problems they encountered, the OSRR succeeded in completing the northern section as far south as Tunitas and the southern section as far north as Scott, with a siding to the lumber mill at Swanton. Large touring cars were used to transport "through" passengers between the two ends of the tracked parts of the system.

MAP OF THE OCEAN SHORE RAILROAD

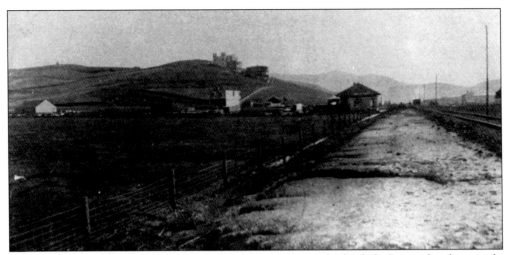

This is the view that visitors saw in 1909 as the train approached Salada Station heading south. Of the buildings visible in the photograph, Anderson's Store (the large white-sided building left of the station), the McCloskey castle, the Wright house (just below the castle), and the Collins house (at the far right) are still standing.

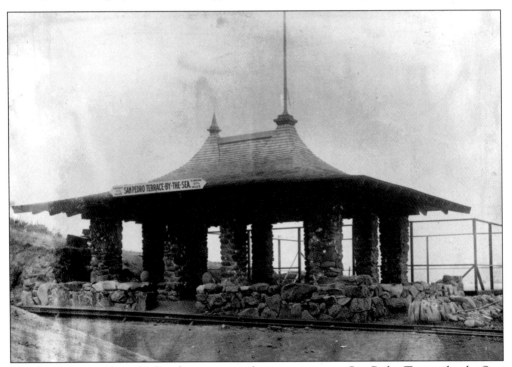

This local Ocean Shore Railroad station went by various names: San Pedro Terrace by the Sea, Pedro Valley and, finally, Tobin. Initially a structure with open sides, it was walled in while in the Pedro Valley name phase. It was later converted into a private residence. The original roof, with its distinctive "Thai" curvature, was blown off in the winter of 1982–83. To conserve repair expense, a more conventional roofline replaced the original exotic design. This location now, along with a handful of others, has a "Shoreside Drive" address along the old Ocean Shore Railroad right-of-way.

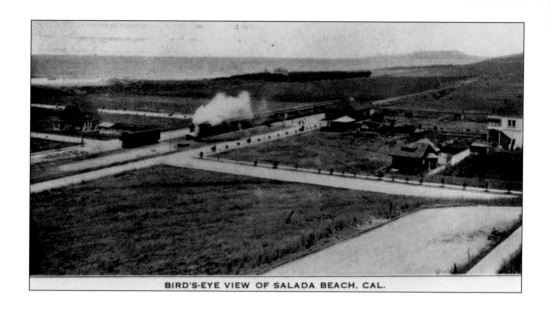

BIRD'S-EYE VIEW OF SALADA BEACH, CAL.

The scene at Salada Beach Station in 1915 was still one of few buildings. The main activity in this district remained farming, especially the Lotti artichoke farm on the flats and the Gray family pea farm near the site of Oceana High School. One impediment to growth was the availability of water. The area around Salada depended on wells and on a spring near the castle for their water supply. As the demand fro water increased, it was common for the wells to run dry by mid-afternoon because the underlying soil was of high clay content, however, more water would seep into the wells overnight.

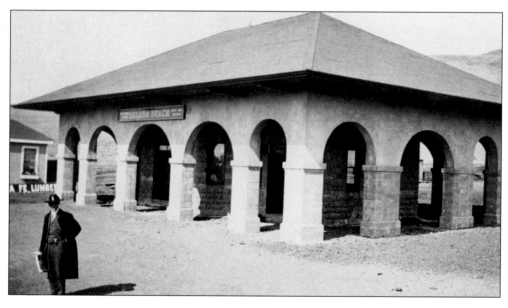

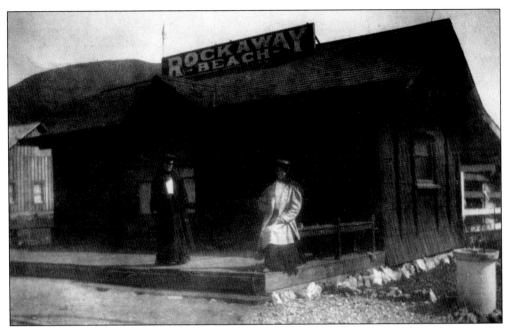

The actual Rockaway Beach railroad station was located at what in 2002 has become the southeast portion of the intersection of Coast Highway, Fassler Avenue, and Rockaway Beach Avenue. After the Ocean Shore Railroad ceased to run, the building's lumber was recycled to become part of the home at 635 Rockaway Beach Avenue. In the 1920s, a Mr. de Hurdler kept dairy cows at Rockaway and was rumored to conceal bootleg whiskey in milk cans at times.

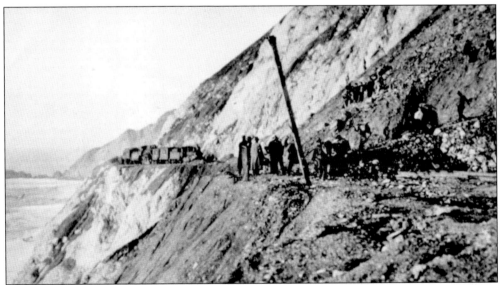

Then as now, the ground along Devil's Slide, just south of Pacifica, was highly unstable. Particularly during rains, the train engineers proceeded with extreme caution along the stretch of track just south of the Shelter Cove tunnel. When slides large enough to prevent passing occurred, the passengers just got off one train, walked carefully across the slide, and boarded another train on the other side. If you have looked down the steep slope by Devil's Slide, you can appreciate the daring of this maneuver.

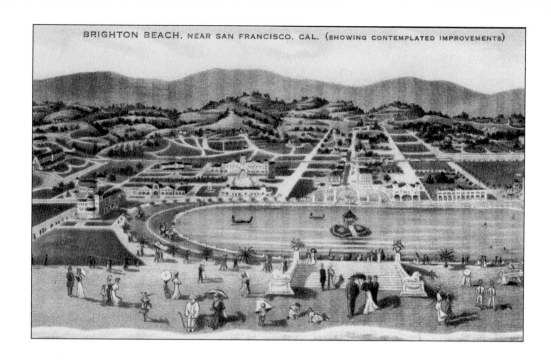

These postcards show the ambitious plans for a big resort at Brighton Beach, next to Laguna Salada, and a casino in Salada Beach. Developers envisioned fabulous amenities, including a recreation center featuring swimming, sun bathing, and spa facilities on a grand scale. Ever-increasing tourists visiting from San Francisco would support the businesses. When the anticipated popularity didn't materialize, neither did the resorts. The Brighton Beach project never even got off the ground, while construction on the casino ceased and wood from the boardwalks and cabanas was recycled.

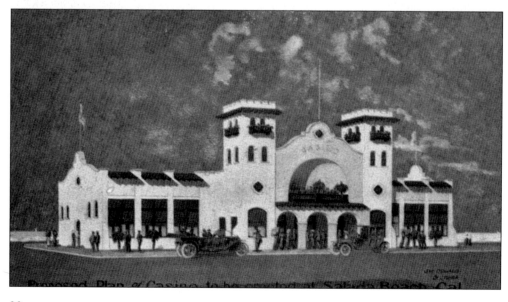

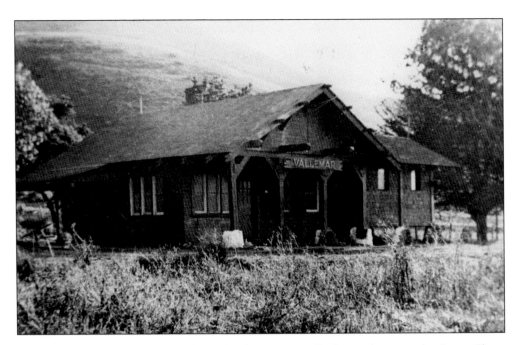

Vallemar Station was built by Vallemar developer George Rich in order to get the Ocean Shore Railroad to stop there and allow passengers to pick up cut flowers, artichokes, and other produce grown in the vicinity. It was in the Rockaway Beach district, which, at the time, extended north past the quarry to the front part of what is now Vallemar. After the railroad ceased operations in 1920, the structure served as a private home and as a restaurant and sports bar under several different managements. The present (2002) operators, Hal and Barbara Ash, have an excellent collection of Ocean Shore Railroad photographs.

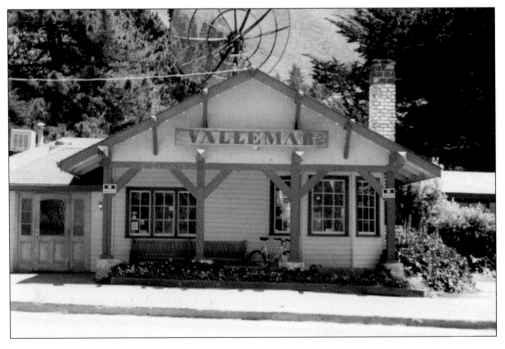

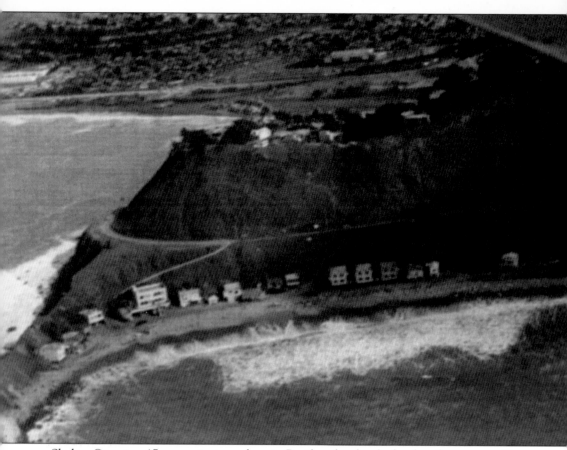

Shelter Cove is a 17-acre private enclave in Pacifica that has had only a few owners: George Ewing, Mr. Scott, Mr. and Mrs. Edward Kirkpatrick, George and Lillian Lewis, Mr. Tischer, Charles and Mary Pavka, James Telegan, and, today, Arno Rohloff. Police captain George Ewing owned the only cabin there in 1908. With the construction of the Ocean Shore Railroad, it became a very popular picnic spot for families from as far away as San Francisco. The "Clipper Ship" bar and restaurant with its big fireplace attracted many customers. During the winter storms of 1913, many cabins washed away. During the Prohibition years, the secluded nature of the cove made it an often-used landing point for illegal Canadian whiskey. Ninety percent of illegal "booze" was made within the USA, but there was also a big demand for the higher quality imported stuff. The wooden cases would be floated ashore at night and stored temporarily in the old Ocean Shore Railroad tunnel between Shelter Cove and Devil's Slide. That convenience ended when Prohibition agents ("prohis") blasted the entrance shut. However, longtime resident Marian Ballew recalled that her son was still able to sneak into the tunnel. In the early 1920s, Scotty (Otterhaus Scott) owned Shelter Cove and fished there. The Pavkas bought Shoreside Drive in December 1941. They bought Shelter Cove in 1949 from George and Lillian Lewis, who had bought it from Mrs. Edward Kirkpatrick in 1929. Mr. Tischer had owned it for an interval between those dates. During a 1960 storm, Tony Navarra's (Lenore Lafayette's father) house was wrecked beyond repair by a boulder which was thrown against the bluff behind the house and then rolled back and right through the house. The Pavkas sold to James Telegan in 1975. It had been open to the public for decades, but he posted it as private property. Since then, only the owner, the renters of the 17 houses there, and invited guests are allowed beyond the parking lot gate. Storms have washed away the access road and residents park their cars and hike around the point to their homes.

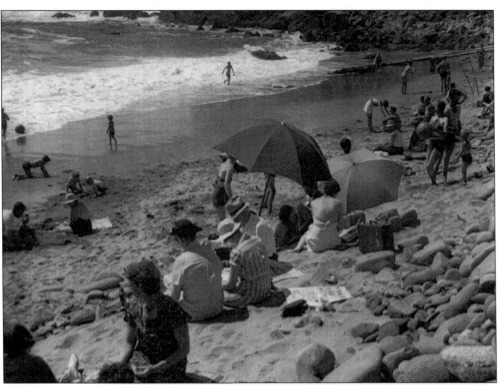

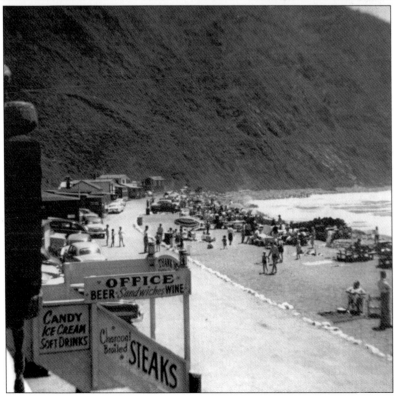

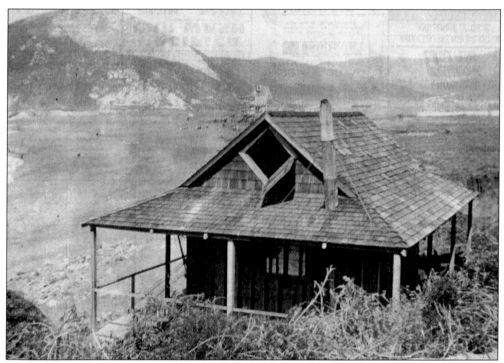

Gustav Einselen's shack on Rockaway Ridge was one of the earliest buildings in Rockaway, dating from the early 1900s. It burned in about 1933 and was not rebuilt. There are currently no structures on the ridge west of Highway 1.

An early shot of Laguna Salada, now part of Sharp Park Golf Course.

34

Harry Danmann emigrated from Helgoland, a small island off northwestern Germany, in 1879. In 1908, he built a hotel and bar to serve Ocean Shore Railroad passengers. At about the age of 40, he became a trustee of the Rockaway Beach School District (the "Rockaway" school site shifted back and forth between Rockaway Beach and Pedro Point depending on where the majority of the pupils lived at the time), and served for well over 50 years in that capacity. After he died in 1954 at 98 years of age, his "Cliff House" became Danmann's Hayloft.

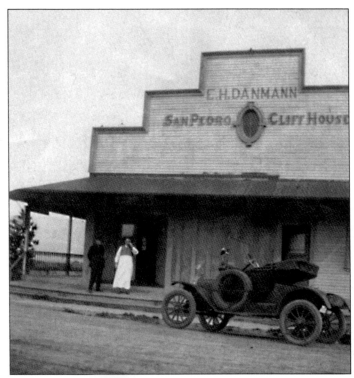

Ray Higgins was the principal developer of Sharp Park, and a civic benefactor. He had purchased the former San Pedro School on Santa Maria Avenue in the early '50s, and after incorporation donated it for use as Pacifica's City Hall. A friend of Andres Oddstad, he spent a spring weekend in 1953 as Oddstad's representative, buying seven ranches in San Pedro Valley. These became the Linda Mar tract subdivisions.

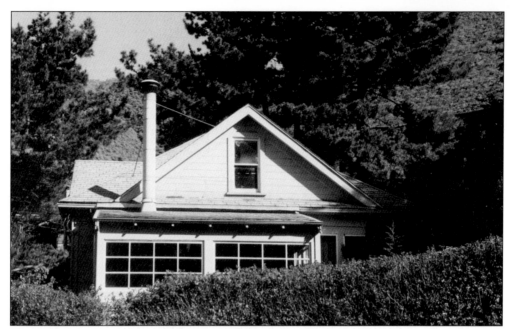

The old Fahey farm house at 685 Canyon Drive in East Sharp Park still exists. The old ranch drew water from a 200-foot deep well that yielded very hard, but fresh water.

The Morrisey house on Monterey Road. The Morrisey family, much to their dismay, was immortalized by Jack London in books like *John Barleycorn*. When London's family leased 75 acres in what is now northern Pacifica in 1883, their plan was to raise potatoes and horses. The Londons were here one year (Jack was seven.) The Morriseys were here for at least 40 years, although they were always renters. An interview with a family member at least 100 years after the London family had left the area demonstrated that London had not been forgotten, nor was he forgiven for his less than complimentary remarks.

Four

BUILDING COMMUNITIES ALONG THE COAST

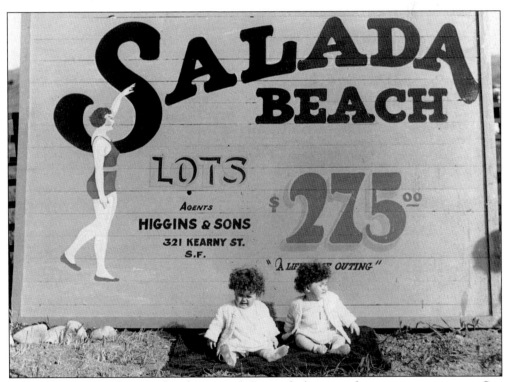

When the Ocean Shore Railroad promised Coastside living with an easy commute to San Francisco, small communities sprang up hoping to capitalize on a population boom. Salada Beach, Brighton Beach and Rockaway Beach offered a lifestyle developers touted as rivaling Eastern seaboard living. "A Lifetime Outing" was the slogan for this Salada Beach billboard that was graced by twin tots to add appeal to the bargain price of only $275 per lot. Today, the 25-foot wide lots are considered substandard, so new projects generally utilize two adjacent lots to satisfy the building requirements.

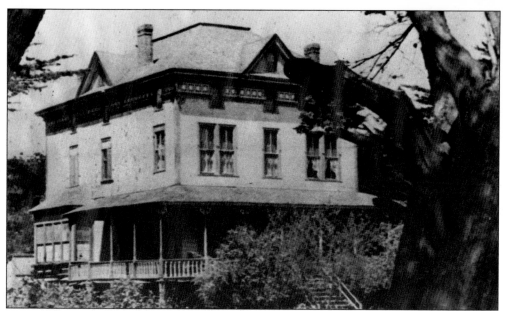

The Comerford-Fahey house, Tornita Villa, a 19th-century residence built by Joseph Comerford, was demolished in the 1950s to make room for Pacific Skies Estates Mobile Home Park. It was the home of Lydia Comerford-Fahey for more than 50 years. Ancestor Michael Comerford emigrated to the San Mateo Coastside in 1853.

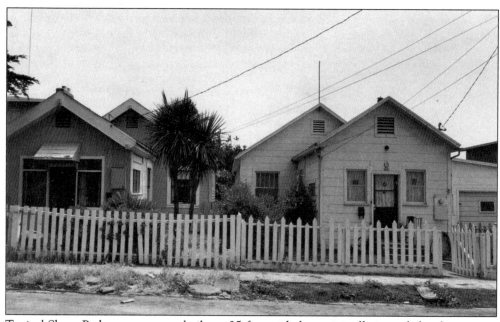

Typical Sharp Park cottages were built on 25-foot wide lots originally intended to be summer homes for San Franciscans. The pictured cottages still exist on Salada Avenue as of 2002. Former coastal ranches were cut up into inexpensive home sites and sold to the weekend picnickers who rode the Ocean Shore Railroad down to the local beaches in the early years of the 20th century. Most of the early houses built on the flat lands of Brighton Beach and Salada Beach (now Sharp Park) were of similar type.

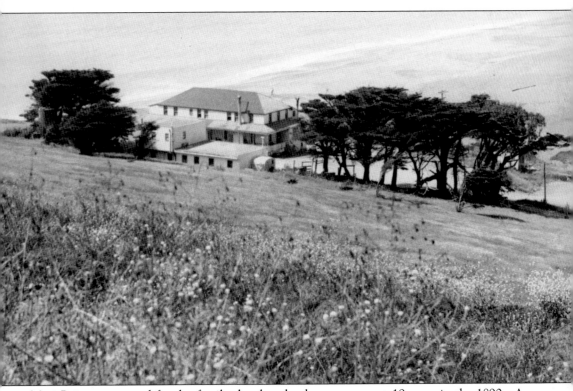

Mori Point was named for the family that bought the westernmost 19 acres in the 1890s. A convenient navigational feature, it was called "Mori's Point" on early charts. The property was initially farmed. In the early 1900s Mr. Hill, then owner of the Rockaway quarry, operated a dragline to bring sand from the ocean bottom up to the first ledge on the bluff where he had a sand and gravel loading business. Goats grazed on the slopes of Mori Point into the 1950s under the care of Greek goatherds. Occasionally, the goats were known to wander into nearby yards for a change of diet. The entire area between Highway 1, Fairway Park, the Rockaway quarry property, and the ocean was acquired for public use by a consortium of environmental organizations including the Pacifica Land Trust and formally turned over to the Golden Gate National Recreation Area at a ceremony on May 5, 2002.

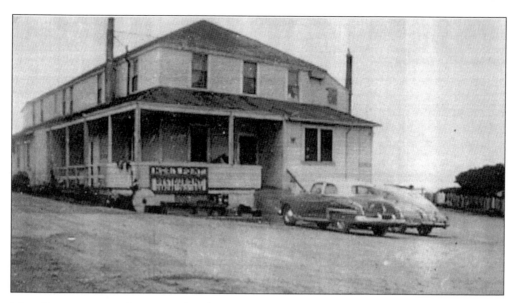

Mori Point was most famous as the site of the Mori Point Restaurant, one of the very lively roadhouses that flourished in the first half of the 20th century and particularly during Prohibition days. As was not uncommon at the time, the restaurant had upstairs rooms to let customers sleep off their inebriation in comfort—and engage in other, more notorious activities. Federal agents raided the place during Prohibition and confiscated a reported "24,000 cases of Scotch." When the place was built, cars could drive all the way around it, but storm waves had undercut the bluff so much by the 1950s that driving around it was no longer possible. The photograph of the restaurant among the trees (page 39) was taken in the late 1950s. After the building burned down, an "out building" remained that was occupied until about 1996. Abandoned and vandalized, it was torn down at the expense of the owners, National Investors Financial, in 1998.

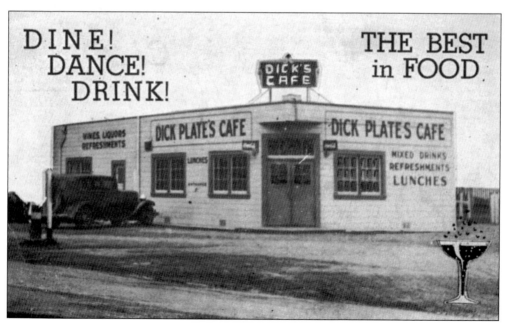

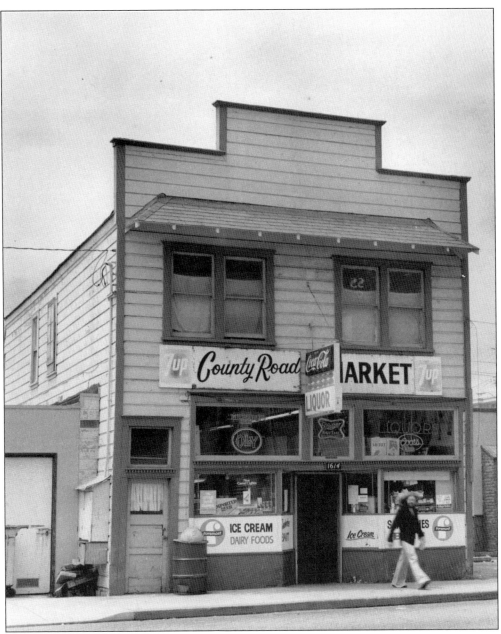

County Road Market on Palmetto Avenue is the oldest continuously operated business in Pacifica and is still being run by a family member of the original owner. A merchant seaman named Dick Plate and his wife, Victoria, came down from San Francisco in 1935 to join a seagoing partner who had acquired the business, also known as Seaside Inn, in 1930. One of the area's first gas stations was opened next door. Plate later opened "Dick Plate's Cafe," (see photo at left) in the adjoining space; it became Al Sohl's cocktail lounge later, and is now a surf shop. The establishment has been the scene of numerous gatherings over the years, including the formation meeting of the Pacifica Lions Club. Don Balkwell, grandson of Dick Plate, now operates the County Road Market.

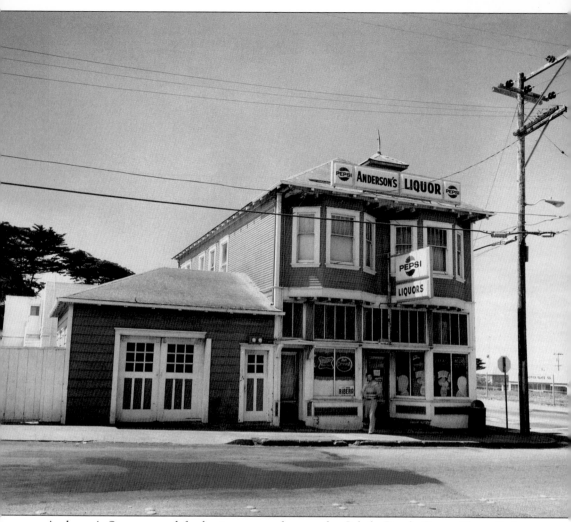

Anderson's Store opened for business next door to the Salada Beach Ocean Shore Railway station in 1907, and remains there today in its brilliant red paint as a highly visible historical structure. It was built by Math Anderson, a young carpenter originally from Bergen, Norway. He met his wife, Bertha, when he delivered groceries to the Castle nearby where she was employed as a maid. Members of the Anderson family operated the store for many years. In recent years, it has been home to the Pacifica Chamber of Commerce and then a series of restaurants and coffee shops.

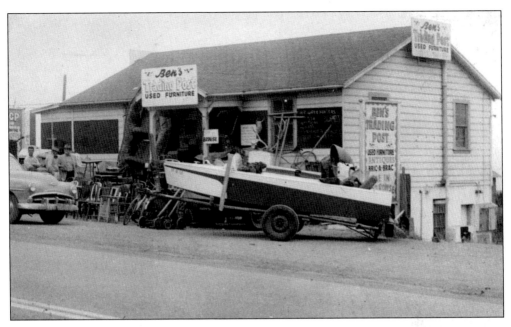

This Rockaway Beach building had a varied history. It was once a dance hall and a winery constructed on former Ocean Shore Railroad right of way. Its owner, James Troglia of Rockaway Beach, offered it for use as a Catholic church in the 1930s, although wine making and storage continued in its basement. Coastside Catholics who had to make the trek to Holy Angels Church in Colma gladly accepted the opportunity and used the building until the Good Shepherd Catholic church opened in Pacific Manor. In the 1950s, Ben Sharp installed his "Ben's Trading Post" into the building. It was one of the first flea market kind of operations and attracted local residents as well as tourists. The structure, at the corner of Rockaway Beach avenue and Coast Highway, was removed in anticipation of the extension of the Highway 1 freeway. The extension was never built.

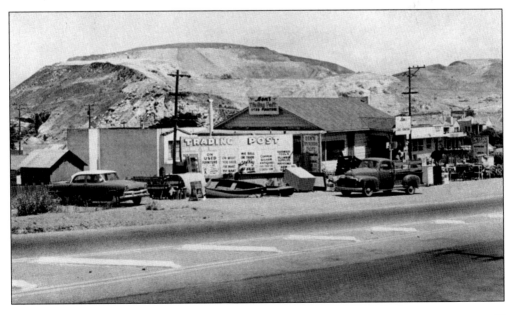

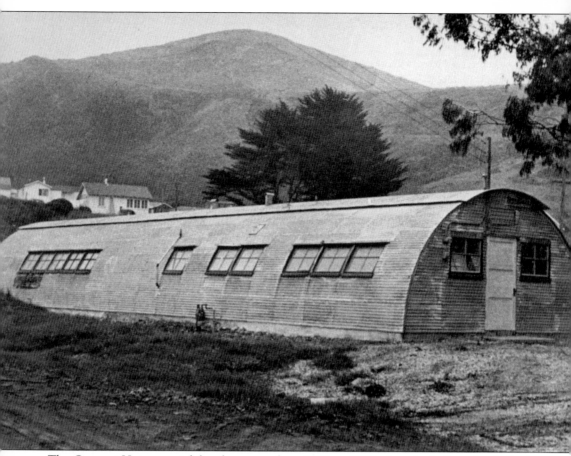

The Quonset Hut was used for classrooms from 1950 to 1956. Acquired after school district unionization (consolidation) in 1949, it was moved to Pomo Park to house the overflow of students. A concrete pad and plumbing had been added when it was moved, but the first teachers felt it was a poor excuse for a classroom. Divided into two rooms, it had neither black boards nor bulletin boards and was very noisy. Temporary racks set up to hang coats collapsed on the first day of school. It rained heavily that year. When the teachers pulled into the lot and stepped into the mud, the mud was so heavy it pulled galoshes off. Once the door was opened on a windy day; the wind caught it, blew it off and down the street. The only contact with Sharp Park School was the pay telephone on the street, often vandalized. Nearby homes were used in an emergency. The building has been used by the Pacifica Coop Nursery School since 1960. Quonset huts were invented to provide a structure that could be stored in compact form and erected in a hurry without heavy equipment. This Quonset hut first served as housing for San Franciscans on "relief" (public assistance) during the Great Depression. It was then part of the Service Administration Unit at the camp set up near the archery range in 1942 to handle Austrian, German, and Italian aliens and POWs. Nearly all of the Italian resident aliens were released, although often with some movement restrictions, after investigation. The POWs were allowed to work in the community during the daytime if they chose to. Many worked as gardeners until released at War's end.

The Collins Home at 185 Carmel in the Sharp Park district was one of the first homes built in Salada Beach. It is contemporary with the McCloskey castle.

This hunting lodge on "Hilton Heights" was built in 1910 and is now a residence hemmed in by more conventional houses and apartments. It typifies the recreational nature of most of the early buildings in Pacifica.

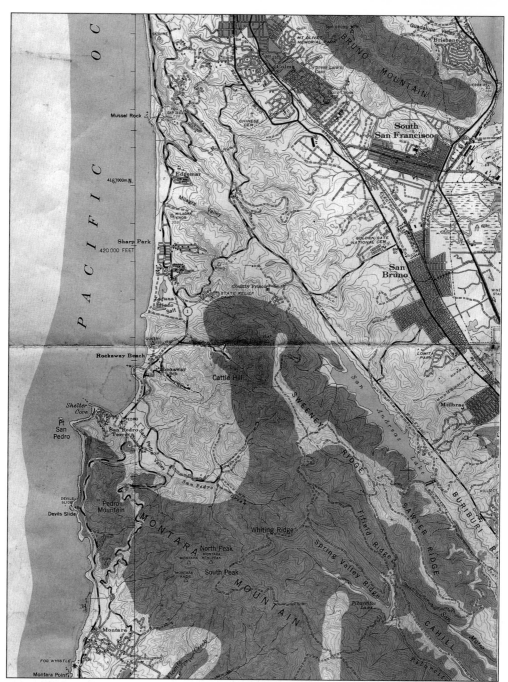

The 1939 U.S. Geological Survey map shows where the State Relief Camp was, in Salt Valley, where the San Francisco Archers archery range is now. Because the property was part of the Sharp family's legacy to San Francisco, it was "down-and-outers" from San Francisco that populated the camp. They were provided room, board, basic medical care, and opportunities to earn a little money. Many of the trees in the valley bounded by Sharp Park Road and east Fairway Park were planted as work projects by residents of the State Relief Camp, for which they earned 25¢ per day.

46

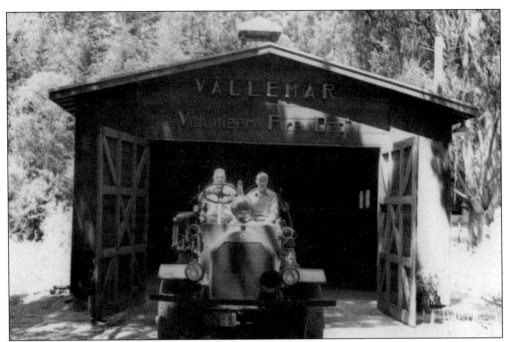

The Vallemar Volunteer Fire Department operated this equipment in the early 1950s. When firefighting services were consolidated after incorporation, this fire house became a community center, then the Moose Lodge in about 1960, and now has been remodeled and expanded as a private residence. George Rich created the unique forested look of Vallemar by importing trees into the little coastal valley.

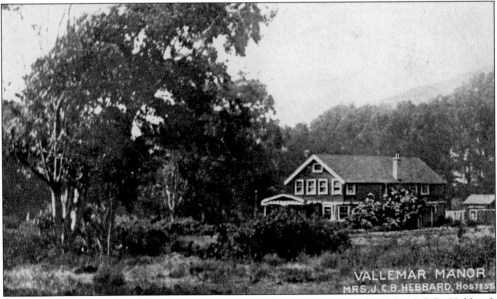

The description on the old postcard picturing Vallemar Manor reads: "Mrs. J.C.B. Hebbard, Hostess. Fifteen miles from San Francisco on the New Coast Side Scenic Boulevard. Take Mission Road to Colma then turn right and follow the boulevard to Vallemar. Then turn to left. Or take Ocean Shore (Railroad) at Twelfth and Mission Streets to Vallemar."

The impressive Wright house, built in 1907, was the first of the large homes on "castle hill" and is sometimes called the "little" castle. The first occupants were Mr. Wright and Mr. Dennison. Mr. Wright was later the horticultural director for the 1939–40 exposition on Treasure Island. The next owners were Helen Smith and her husband, in whose names the title was recorded in 1912. A Mr. Alpaw bought the house in 1957, after which it has belonged to a number of owners.

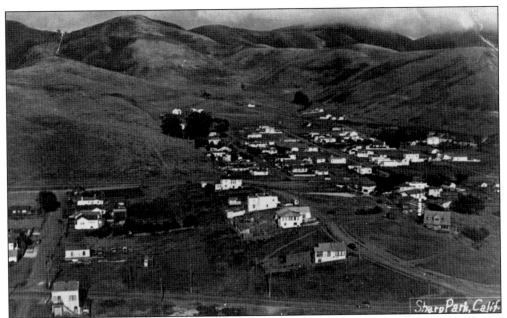

This is a 1936 aerial view of the Sharp Park district.

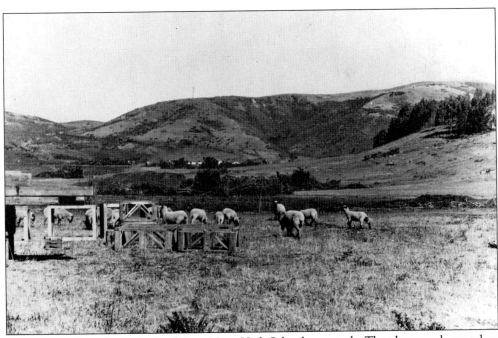

Sheep graze where the students of Terra Nova High School now study. The photograph was taken by Alice Blankfort, co-publisher of the *Pacifica Tribune* in the late 1950s. Other pursuits that flourished in the back of San Pedro Valley before the era of housing developments and schools were vegetable and flower agriculture, a hog ranch, and a riding stable (which still exists).

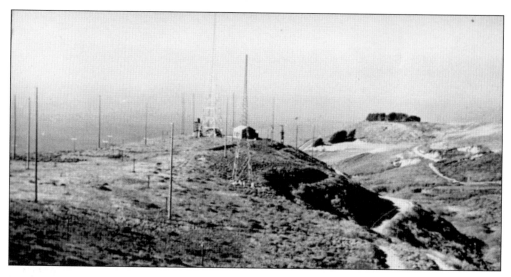

In an area south of Mussel Rock, now covered by homes in the Fairmont West area, commuters enroute on old Coast Highway enjoyed a glimpse of nine giant towers, two of them 250 feet high. Morse code messages flowed in and out of the towers, to and from various places around the world. They were the visible parts of a vast communication network operated by Globe Wireless, originating in 1926 as Dollaradio, serving the steamship company of the same name. In 1929, Station KTK linked its owner, R. Stanley Dollar, on a ship at sea, with the German Graf Zeppelin by Morse code. The station's communications with Admiral Richard E. Byrd from his Little America radio station brought the first word from the Antarctic expedition to the small station headquarters, now a private residence on north Palmetto Avenue. Construction of the Edgemar freeway caused the company to move its operations south of Half Moon Bay.

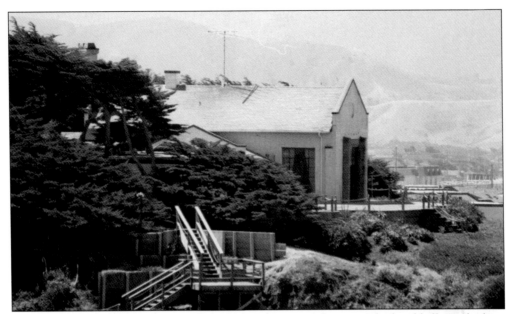

Part of the original Dollaradio complex is now a private residence perched on bluffs overlooking the Pacific Ocean.

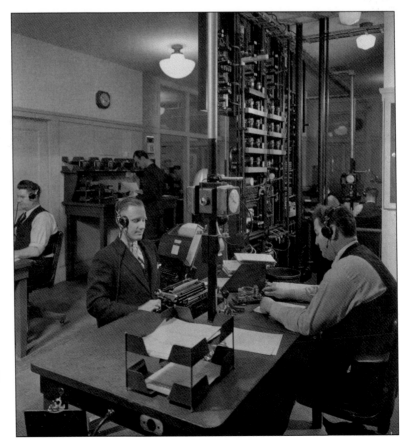

Dollaradio and Globe Wireless were busy places of business during their years of operation in the early part of the 20th century.

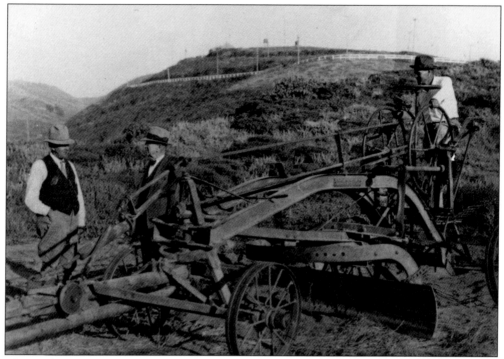

This grader carved out the roads in the north end of town. Dollaradio antennae can be seen in the background.

Each of the old districts had its own volunteer fire department. The Pedro Valley Volunteer Fire Department, formed in 1944, was responsible for fire suppression between Montara Mountain and Rockaway Beach. It also ran a first aid station and participated in civil defense. Jack Rothy was the first chief and Joe Fulford the first secretary. The men in the photograph, from left to right, were Frenchy Bouly, Jim Kibblewhite Jr., and Bob Keating. The volunteers also built the Pedro Point Firehouse, with help from their wives and other local residents. Bob Keating did the wiring.

Five

GUARDING THE COAST
AND GROWING
AFTER THE WAR

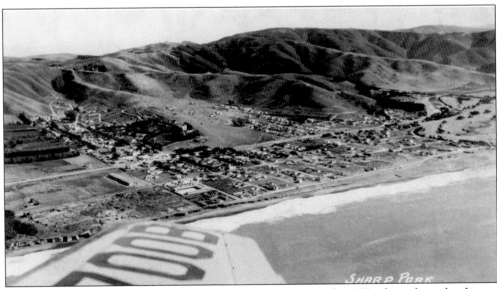

This view of Sharp Park from the air in the late 1940s or early 1950s shows how the district looked before incorporation, before the freeway forced relocation of some stores and destruction of others. The Sharp Park Sanitary District, one of the first forms of formal community organization in the area, was absorbed by the City of Pacifica Public Works Department. The Sharp Park Volunteer Fire Department, with its whist party Fundraisers, also became a memory as it merged with the city-wide full-time fire department.

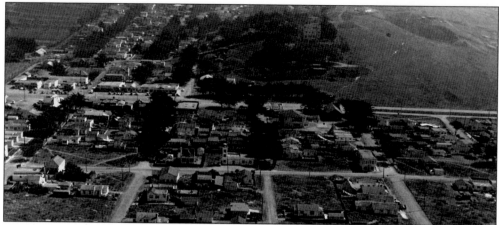

During the Second World War, the U.S. Coast Guard took advantage of the panoramic view from the McCloskey castle to set up a communications center with guard dogs used as night sentries. There was also a house near the Skull Kracker tavern on Beach Boulevard in which dogs were kept for wartime beach patrols. The increase in residents created a water shortage in the area, and the result was that the coastside from Mussel Rock to Pedro Point was tied into the Hetch Hetchy water system. After the Coast Guard moved out of the castle, the place was in need of repairs. The issue had not been resolved by the time Sam Mazza, who died in 2002 at the age of 96, bought the castle. Known as Sam's Castle for four decades, the Pacifica landmark offered a playful sense of fun to passersby on the highway. It was filled with Sam's eclectic antique collection, ranging from a suit of armor to a king's throne. Nearby, where Good Shepherd Catholic Church and Chapel by the Sea are now, the Malavear family raised peas and cabbage to help meet the increased demand for food in the Bay Area.

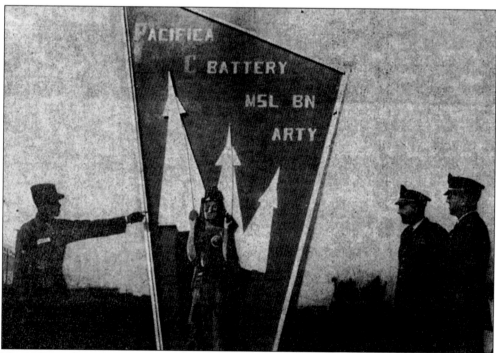

The NIKE military base chose Pacifica as its mascot during the Cold War.

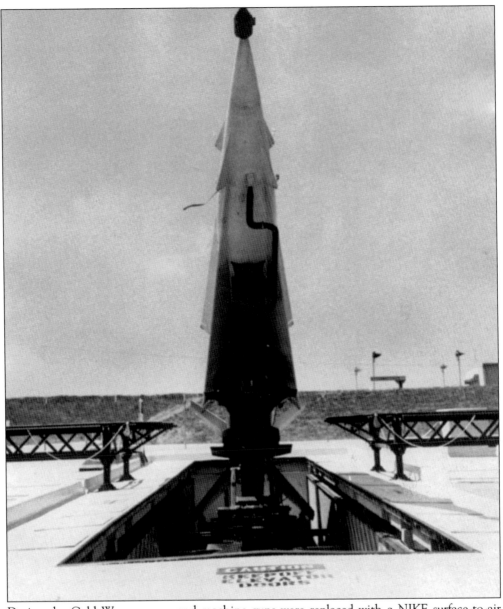

During the Cold War, cannon and machine guns were replaced with a NIKE surface-to-air missile site, one of 52 ringing the U.S. The NIKE battery of 97 men stationed on Sweeney Ridge adopted the image of Pacifica for their unit. It was run by regular Army troops from 1954 to 1963, and by National Guard troops from 1963 until it was decommissioned in 1974. The National Guard won top honors in operational exercises in New Mexico. A good relationship existed between Pacificans and the troops. Army personnel came down to help with the flood of 1955–56, and local Red Cross volunteers took coffee and doughnuts to the crews. In the 1960s, local residents Connie Mason (Brown) and Marian Ballew were selected to go on a week-long Air Force public relations tour for their record of community service. They saw a missile fired at a base in El Paso, visited the "missile garden" at White Sands, New Mexico and went through the North American Air Defense facility where they were given a preview of the plans for the Apollo moon shot.

Of all those who perceived the potential of the north coastside, Andres Oddstad was the one who did the most about it. Working with realtor Ray Higgins, pioneer coast developer Andy Oddstad negotiated in one weekend to buy seven Pedro Valley ranches which are today's Linda Mar. His firms also built Park Pacifica and other projects, including Eureka Square Shopping Center. A school, a major street, and a park were named for Oddstad, whose companies had plans to develop more homes. At the time of his death in an auto collision in 1964 (a wrong-way freeway off-ramp crash), he was 44.

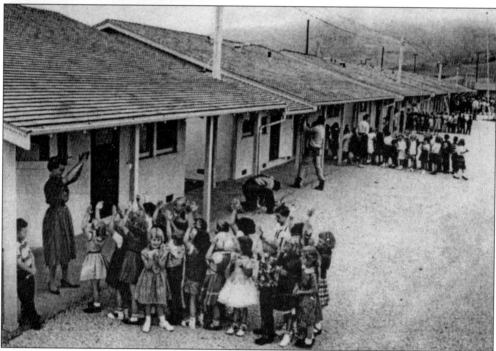

Pedro Valley/Oddstad Convertible School opened in 1954 and closed in 1958. Andy Oddstad, the developer of the Linda Mar tracts, was building houses so fast that the school district could not keep up with the growing student population. In 1954 he set aside 11 houses that were adjacent to the site of the future Pedro Valley School. These were to be temporarily used for classrooms until the new school could be built. The interior walls and garages were eliminated and a classroom was made of each. Chalkboards and bulletin boards were placed around the walls. A lavatory was enclosed in the space of the kitchen. The buildings were linked in the rear by a covered promenade. The backyard areas were covered with gravel for use as a playground. Four more houses were added later. The innovative idea drew nationwide interest. Both *Time* and *Life* magazines had articles about the school. After Pedro Valley School opened in 1956, the buildings were gradually restored and sold as houses.

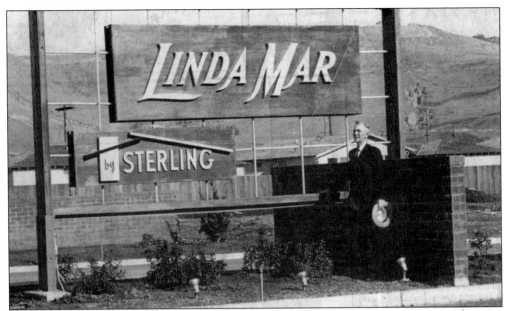

The Reverend Herschel Harkins beckons prospective homeowners to the affordability of the new subdivision known as Linda Mar in the early 1950s. The district continues to be the largest population area in Pacifica. Likewise, it is the largest geographical area, stretching several miles east into the large San Pedro Valley.

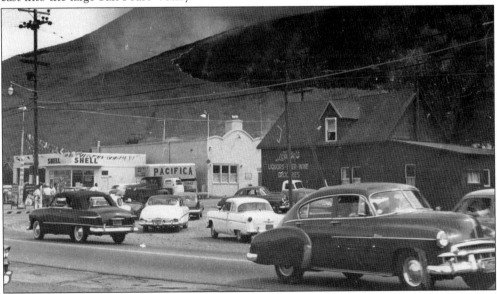

Coast Highway 1 and Rockaway Beach Avenue, (formerly Hewitt Avenue) looked like this before Fassler Avenue was completed. This 1958 photo shows a brush fire on Cattle Hill. The Rockaway General Store (last known as Louise's Store) was built sometime before 1922. The Rockaway Post Office shared the store. At some point it became the Petersen General Store, run by Mr. and Mrs. Dieleff Petersen. James Troglia purchased it in 1922. From 1937 to 1939 the operator was Jenny Bicknell. In 1939 Louise Cerri leased the store from Mrs. Florence Graziani, James Troglia's daughter. In 1963 Louise actually purchased the store, which was demolished in the early '70s to make room for Fassler Avenue.

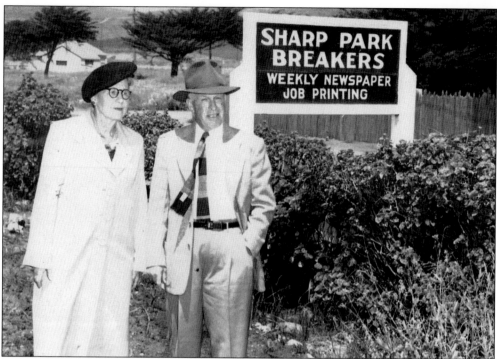

Three significant people were the most involved in publishing the *Sharp Park Breakers* from 1937 to 1958. Maude Pitsche Farrell, above left, and her first husband, William E. Pitsche, founded the Coastside's first newspaper when the area was "mostly fields of artichokes and a few scattered houses." Maude published it alone after Bill's death, until she married Ed Farrell, shown above, who became an associate administrator of the paper. The *Breakers* ceased publication in 1958 when it was acquired by the *Coastside Tribune*. The *Breakers* opposed incorporation, the *Tribune* endorsed it.

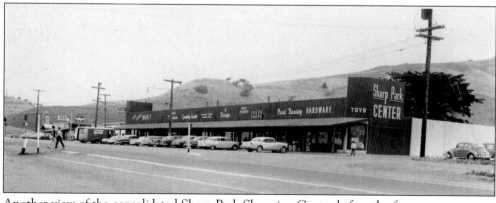

Another view of the consolidated Sharp Park Shopping Center before the freeway came.

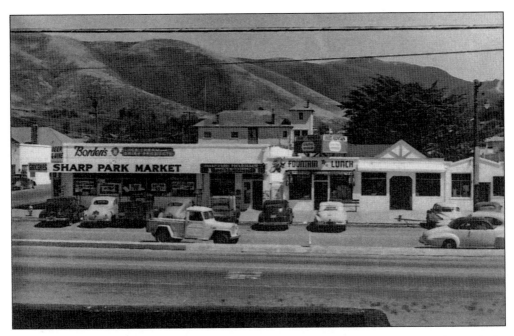

The Sharp Park shopping strip extended along Coast Highway below the castle until the freeway extension required moving or demolishing these buildings. The shopping district had been more scattered and disorganized until Ray Higgins arranged to have this grouping consolidated. The town library is the building to the left of the post office. A number of similar stores are still in use along present-day Francisco Boulevard from the corner of Paloma Avenue south. An interesting feature of this panorama is the variety of cars in use in the 1950s.

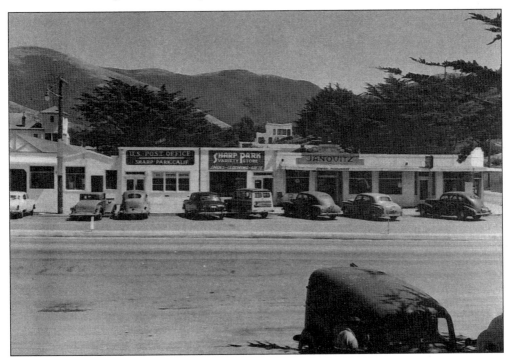

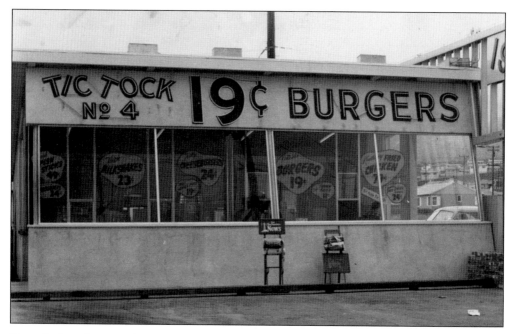

Sharp Park in the 1950s had one of the 19¢ hamburger joints that had recently come on the scene. As the fast food idea caught on, McDonald's franchises came to dominate the low cost hamburger business. Frowned on by some people, the inexpensive hamburgers helped many students stretch their college budgets. Another sign of the times was 29¢ gasoline. That's actually quite a bit more expensive, relative to the cost of living index, than the cost of gasoline in 2002.

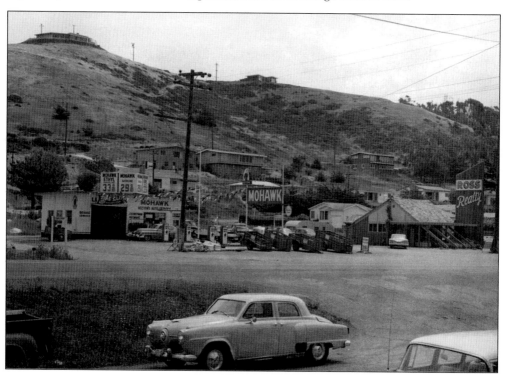

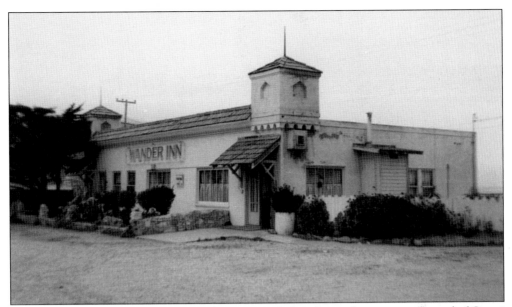

The Wander Inn was once a very popular watering hole right on the ocean at the end of Crespi Drive. It was later used, briefly, as a teen activity center and then was burned to the ground. All that's left are pictures and a little bit of foundation on the beach.

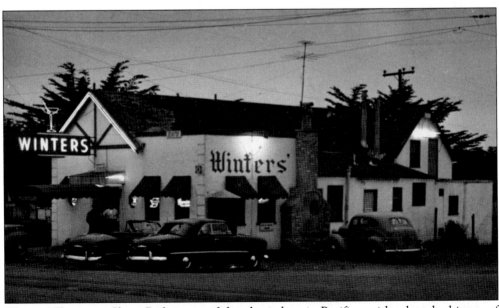

Winters' Tavern in Sharp Park is one of the classic bars in Pacifica, with a lengthy history of its own. It's still around, under new ownership.

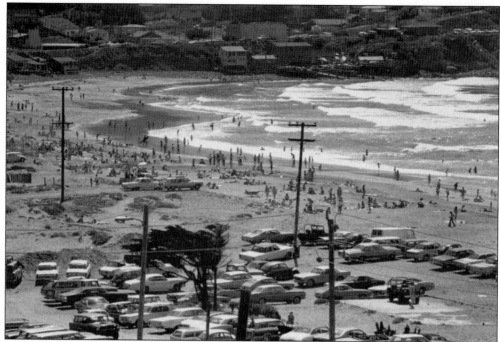

The Linda Mar Beach in the 1950s was every bit as popular as it is today. Cars are no longer allowed to park on the beach, of course.

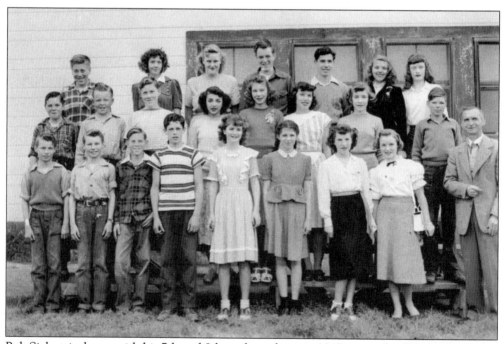

Bob Siebert is shown with his 7th and 8th grade students in 1947, soon after World War II. He had 54 students in 4 grades in San Pedro School. Bob also worked with a group of Boy Scouts to post street names on Sharp Park corners. The PTA sponsored the Scout troop. The pay had been a mere $200 per month, but it doubled when the War ended.

Six

Incorporating a
New City:
Pacifica is Born

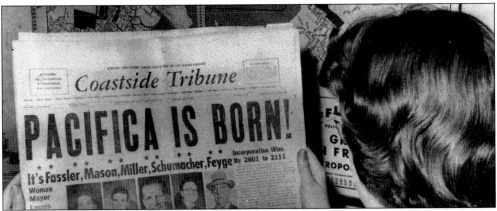

The Coastside Tribune took out its big type to report incorporation election results in November 1957. Photos of the five new council members elected from a field of about two dozen hopefuls appeared on the front page of the newspaper which became the *Pacifica Tribune* a short time later. The winners were Jean Fassler, who was chosen the first mayor and later served as a county supervisor; Harold Feyge (the second and fifth mayor); Don Miller; George Mason (the fourth mayor); and Gerry Schumacher (the third mayor). Incorporation won by a vote of 2,603 to 2,113. The first official City Council meeting was held on the stage at Vallemar School, then the largest auditorium in town. Councilman Gerry Schumacher opened the meeting and, as anticipated, Councilwoman Jean Fassler, who got the most incorporation election votes, was elected mayor.

Incorporation was a controversial matter in 1957 along the coastside. This sign advertised a meeting for opponents held at the Rockaway Beach Progressive Club building across the street from Louise's Store (the building houses "Nails by Lisa" in 2002). Committees for both pro and con sometimes held meetings in Coastside Hall, the former San Pedro schoolhouse, and now City Hall.

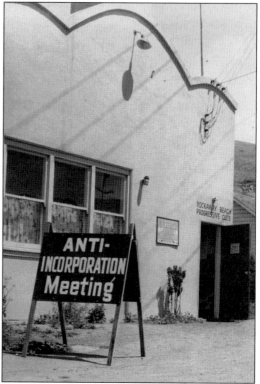

These newly elected council members and friends celebrate their incorporation victory. Pictured from left are: (back row) council member-elect Don Miller, council member-elect Gerry Schumacher, council member-elect George Mason, Joe Fassler, and Lowell Blankfort, publisher of the *Coastside Tribune*; (front row) Marty Miller, soon-to-be mayor Jean Fassler, Connie Mason (Brown), and *Tribune* co-publisher Alice Blankfort. Many of the city committee's pre-incorporation meetings were held in Connie's parlor.

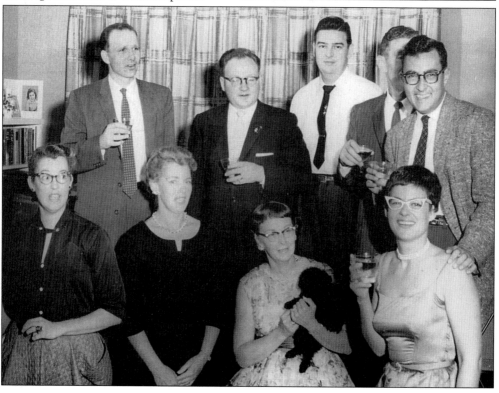

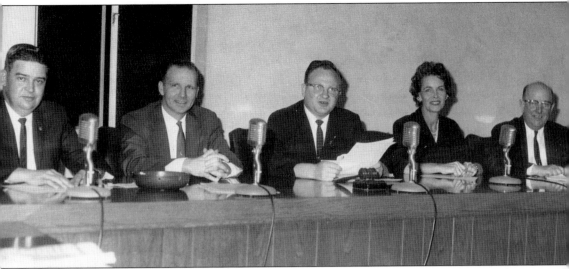

The first official city council meeting was held on the stage at Vallemar School, then the largest auditorium in town. Councilman Gerry Schumacher opened the meeting and, as anticipated, councilwoman Jean Fassler, who got the most incorporation election votes, was elected mayor. Pictured from left are George Mason, Don Miller, Gerry Schumacher, Jean Fassler, and Harold Feyge.

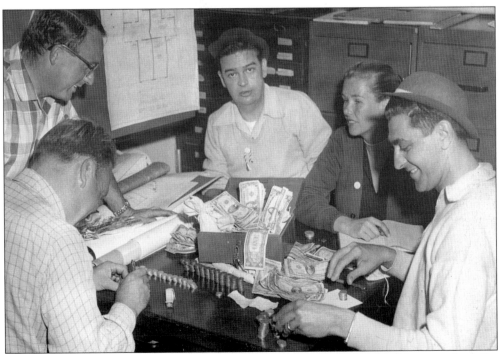

Members of the city committee tabulate the profit from a 1957 carnival held to raise funds for the incorporation election campaign. Pictured are committee chair George Mason, center, with Joyce Christian (whose last minute drive to Redwood City with documents to meet a deadline kept the effort alive) and Ralph Barkey, far right, who designed the city seal incorporating statue of "Pacifica" from the San Francisco World's Fair.

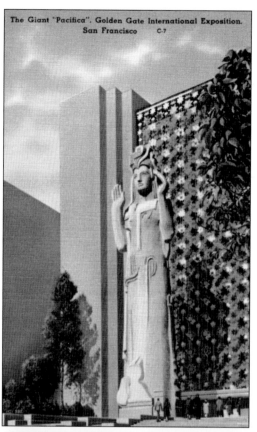

The city's name, "Pacifica," was adopted after a series of votes to narrow down the many choices. "Coastside" got the most votes on the first ballot, but not a majority. "Pacifica" finally won out over that and 17 other possibilities: Costa del Norte, El Sanchez, Fair Haven, Higginsville, Hillside Valley, Ocean View, Ortega, Ocean Hills, Pacific Manor, Pacific Shores, Pedro Valley, Rancho del Mar, San Distos, Sea Fort, Seven Cities, Sharp Park, and Vista Mar. Pacifica was the name given the 80-foot tall theme statue designed by Ralph Stackpole symbolizing the unity of peoples around the Pacific basin that stood in the Court of Nations on Treasure Island at the 1939-40 Golden Gate International Exposition. This was the great event that prompted FDR to say, "San Francisco knows how!" Two of the three-foot tall models made by the sculptor, Ralph Stackpole, can be seen today—the one at City Hall was donated by the estate of Marshall Dill, president of the Exposition, and the one in the city council chambers was donated by the National Federation of Business and Professional Women. The face of the statue is incorporated into the official city seal.

STATUE OF "PACIFICA" AT ENTRANCE TO CAVALCADE OF THE GOLDEN WEST

The first city manager, Karl Baldwin, had the task of getting the city organization up and running. He served from February 1958 to November 1966, then headed for Vietnam as a USAID representative. He and his wife Eileen are currently residents of Pedro Point. The other Pacifica city managers have been: C.W. Masonheimer, 1967–1970; James A. Swayne, 1970–1972; David J. Thompson, 1972–1974; Donald G. Weidner, 1974–1978; Albert R. St. Cyr, 1978–1981; David G. Finigan, 1981–1985; Dan Pincetich, 1985–1994; Charles English, 1994–1997; and David Carmany, 1997 to the present time.

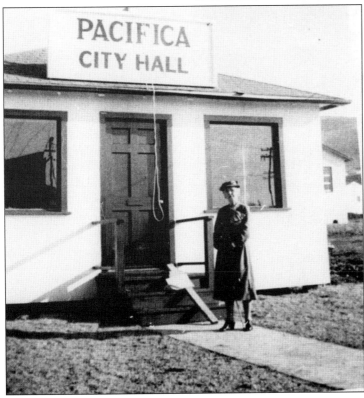

This building has had many lives. Originally a real estate office on Cristobal Street, now Oceana Boulevard, it was donated by Ray Higgins to Pacifica in 1957 as the first City Hall. After San Pedro School was remodeled to become the new City Hall in 1958, it was moved to 184 Paloma Avenue, where it housed an answering service for years. Now it is a private residence. That's Lydia Comerford Fahey standing in front.

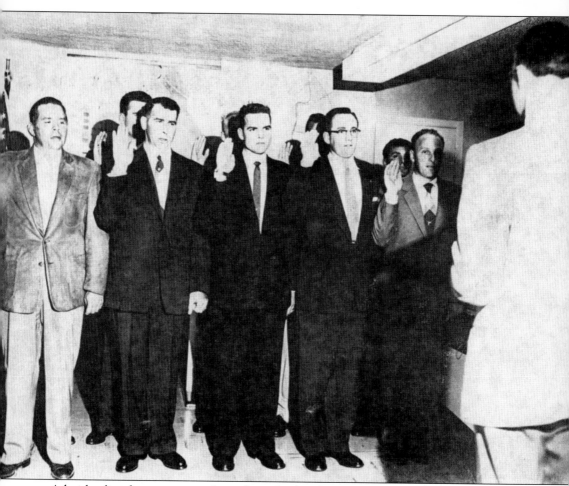

A local police department was formed to take the place of San Mateo County contract service as the result of a feasibility study by Dan Martin, safety chairman of the Sharp Park PTA, and John Geary. A recall effort by opponents of the change failed to unseat Harold Feyge, Gerry Schumacher, and George Mason from the city council in 1959. The first police chief, Neil Tremaine, had been police chief of Tracy when he had to run some destructive motorcyclists out of town—the incident used in the movie *The Wild Ones*. Chief Tremaine, being sworn in at far left in 1959 by city manager Karl Baldwin, set high standards for the department. Joining him are Paul Averiett, Robert Greer, Donald Joice, Al Tebaldi, Otto Saltenberger, Dick Schaldach, Robert Oglesby, and Ray Shipley.

There were several small water operations that were merged to form the North Coast County Water District. The Pendolas ran the Vallemar County Water District, which was formed to support commercial flower growing (violets, cala lilies, daffodils, sweet peas, marigolds). They operated wells, located with the help of a water dowser, and a pumping station on Calera Creek. Angelo Pendola maintained the pumps and his older daughter made the rounds in a Model T Ford while Lorraine (now Mrs. Nick Gust) rode on the running board, lifting the meter covers and calling out the readings. Angelo's wife Lena was one of the original NCCWD board members, along with A.D. Brunet, Harry Bateman, A.G. Marlet, and F. Loney.

Russ Conroy, who was one of the longest-serving elected public official in California during the last half century, ran for the board at a time of sharp controversy between developer Andy Oddstad and the water agency. Russ won ("to his surprise," he said) and served more than 40 years. Before his death, he was made the district's only Emeritus Director.

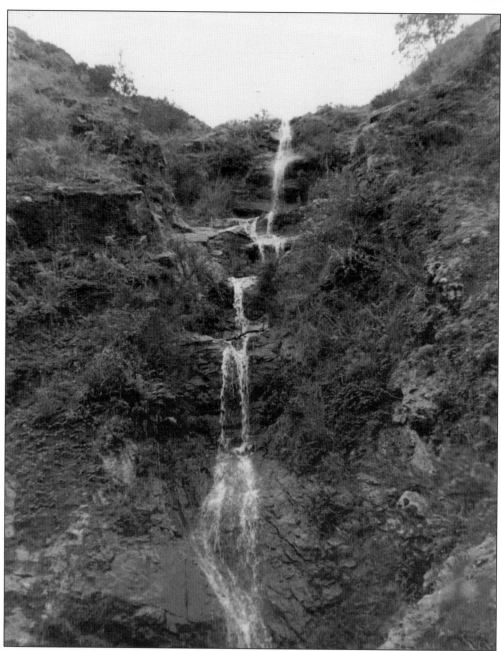

Pacifica has an amazing number of scenic features; this is our waterfall, Brooks Falls. It is located on a south fork of San Pedro Creek, upstream from the small water treatment plant. At one time, there was also a Brooks Lake in town. On the official maps of the late 1800s, two lakes were shown near Skyline Boulevard, one near Hickey Boulevard named Laguna Alta and one near the intersection with Highway 1 named simply Laguna. This second lake, which dried up in summertime, was on the edge of a parcel owned by P. Brooks, so it was sometimes called Brooks Lake until it was drained in the 1950s. San Pedro Valley County Park is a gorgeous area of protected space made possible by the generosity and vision of the North Coast County Water District, which owns much of the land.

Six

PACIFICA'S FIRST 45 YEARS:

PEOPLE, POLITICS, SCHOOLS, DISASTERS, AND ALSO SOME FUN

The remodeled former San Pedro School was dedicated as the new City Hall in 1958. Over the years, the City Hall has become the centerpiece of our civic center. The building that houses the Planning Department and the Parks, Beaches, and Recreation Department was formerly a post office, the police station a former church, and the police annex a former school bus barn. The City Hall building has suffered slow damage from dampness, particularly in the basement level, and—although an official Pacifica historic building—will have to be replaced in the relatively near future.

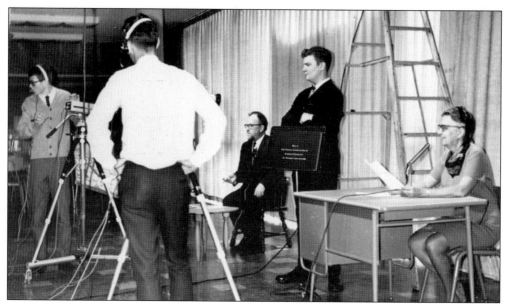

Local cable television (initially Channel 8, and now Channel 26) has played an important role in keeping the public informed on government issues. This photo shows the dedication broadcast with Mrs. Grace McCarthy behind the microphone. The founding staff members are gathered in the other photo. The station has an active broadcast schedule which includes televising city council meetings, planning commission meetings, school board meetings, frequent historical programs, coastal features, and entertainment shows.

Angel Stewart was a talented and generous citizen who gave of her time and her abilities to the whole community, but didn't take herself too seriously. She was an officer, and often the secretary, of various civic organizations. A talented landscape painter, she was well known for her waves, rocky cliffs, and her outhouses. She was a longtime member of the library staff. Pacifica's first city historian, she bragged that the history of the city was stowed under her bed. Pacifica has a long line of local historians who keep the city's records close to their hearts (and homes).

Bill Drake was the owner, publisher, editor, and primary force behind the *Pacifica Tribune* from 1959 until 1989. He was hardly ever without his trademark bowtie, not to mention a notebook. He was instrumental in the creation of this book of images.

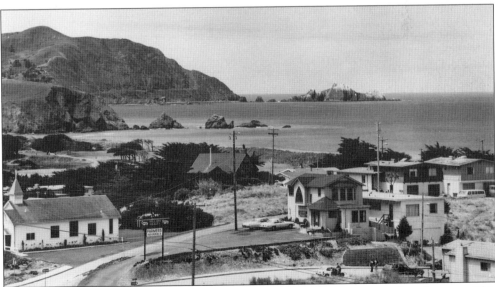

The unique oceanfront views from Pacifica homes always have generated excitement. This view from the north, looking south, is still an enchanting reality.

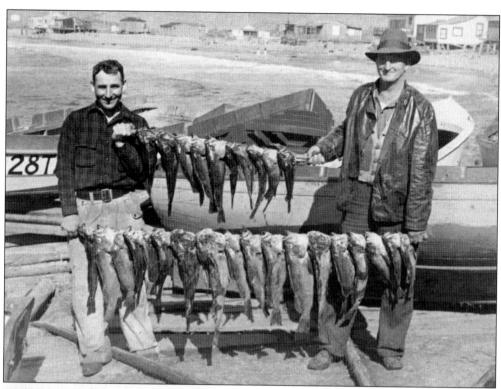

Charles Pavka and a friend brought in plenty of fish to feed family and friends on this day. Mr. Pavka was one of the early owners of Shelter Cove and of the boathouse on Shoreside Drive. Many picnickers rode the Ocean Shore Railroad down from San Francisco to enjoy the beaches and the fresh catch of the day.

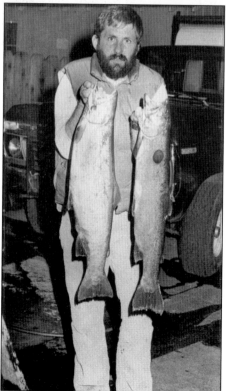

Ranger Jess Gilley is not proudly showing off the catch of the day. The Steelhead trout in the picture died from chlorine poisoning in 1988, the result of carelessly draining the contents of the Terra Nova High School swimming pool into storm drains flowing to San Pedro Creek.

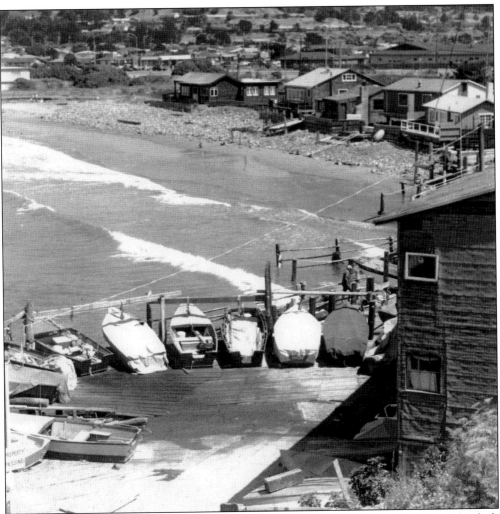

The boat dock has been a shoreline fixture for nearly 100 years. In 1941, Morris Nichols managed the boat ramp and lived in Tobin Station. Quintin Tavares owned and operated the boat ramp by 1949. Dick Keating runs the boathouse and builds surfboards at the south end of Linda Mar Beach. In his younger days, he made an impressive record in surfing contests, including the first "big wave" (it wasn't initially billed as a big wave contest, but the weather created waves of unusual size) National California Surfing championship at Santa Cruz in 1964. Dick's wife, Penny, has earned a fine reputation and awards for helping preserve steelhead spawning in San Pedro Creek and teaching youngsters the value of conservation.

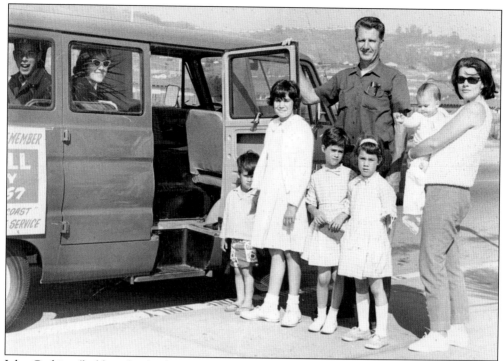

John Cushing (holding the door) and wife Mary started El Mar Transit (also known as the "Little Red Bus," the name conferred by the first official passenger, Bill Drake) in 1963 with a 16-passenger former school bus painted red for better visibility in fog. The line expanded until buses ran all over Pacifica and up the Fassler Avenue route to the Discovery Site for barbecues on Sweeney Ridge. They operated for about nine years, but folded when Serramonte Shopping Center and BART started—destinations for which the Little Red Bus could not get a permit—and SamTrans.

The Pillar of Fire Church purchased parcels at the corner of Seville Drive and Linda Mar Boulevard, eventually establishing the Alma Heights Christian Academy campus. This building was constructed in the early 1950s under the guidance of Reverend Orland Wolfram.

The garage of this Linda Mar rancher was extended to make it spacious enough to house the original St. Peter's Catholic Church in Pacifica. The founding pastor, Father Francis E. Rielly, started his Pacifica assignment in the converted former residence on Adobe Drive and served Pacifica from 1956 to 1966. Under his leadership, the second St. Peter's, an "umbrella-like church in the round," was completed in 1963. Unfortunately, the structure could not keep moisture out and dry rot rendered the roof unsafe. When that was discovered, services moved to the multi-purpose room from 1976 to 1989. The third and current St. Peter Catholic Church was built in 1989.

TROUT in this pond are 11-15 INCHES AT 10¢ PER OZ. (about $.80-$2. each)
Penalty: Fish thrown back in this pond are $3. each

John Gay built a trout farm on the south fork of San Pedro Creek. After years of successful operation, the North Coast County Water District indicated they wanted to buy the property so the stream would be undisturbed. NCCWD had a small filtration plant on the stream which provided about two percent of the Pacifica water supply when rainfall was good. Gay was holding out for a higher price than had been offered when a 1962 storm dropped so much rain that the trout farm was literally washed away.

The North Coastside County Fire Suppression district was formed in 1947. Each populated district had a volunteer fire department; volunteers were paid $1 for each response. Regular pay started in 1953. Here, members of the Pacifica Fire Department (that's Cal Hinton, former fire chief and current city councilman wielding a hacksaw in the middle) sawed off a toilet float from their former fire station to use as part of a time capsule as they moved into the new Linda Mar fire station in December 1975. Ed Gerdler, Capt. Al Deshes, Fire Chief Edwin Greer, and Leo Gerdler were with Hinton.

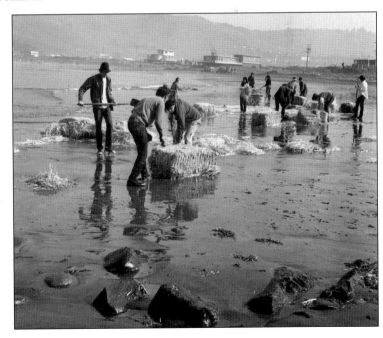

Hundreds of volunteers battled the Linda Mar Beach oil spill in 1971. Scores of birds were rescued and cleaned and the shoreline was scoured to remove oil from the Standard oil tanker.

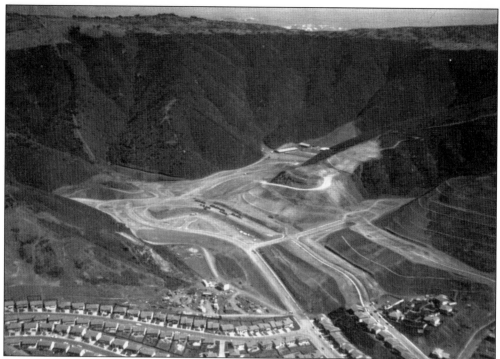

This is the Linda Mar Valley, with the expansion of the Park Pacifica neighborhood under construction.

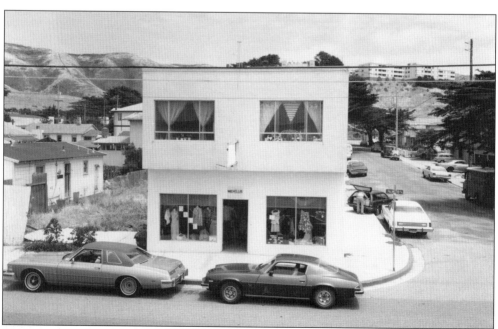

The sometimes-scandalous Salada Hotel at the corner of Salada Avenue and Palmetto has undergone numerous changes in appearance, use, and ownership in its nine decades. In recent years it has served as a beauty salon and an upholstery shop. At one time it was the location of Pete and Anna's Restaurant.

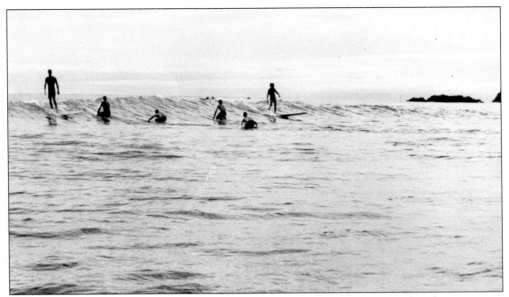

Surfing caught on in the cold waters off Pacifica even before wetsuits. Local surfers are active in preserving the quality of the environment, too. The Surfrider Foundation brought a successful legal action in the 1960s to clean up the extremely polluted waters outside of Humboldt Bay. Surfrider Foundation president Rob Caughlin, along with surfer/attorney Mark Massara, and ex-Congressman Pete McCloskey got the offending paper companies to install treatment facilities which ended the blight of black surf there. Local surfers continue to help monitor San Pedro Creek water quality, which periodically requires pollution warnings.

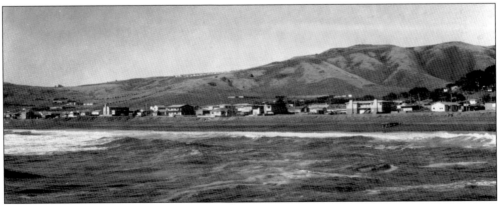

Pacifica's coastline is picturesque and always has been.

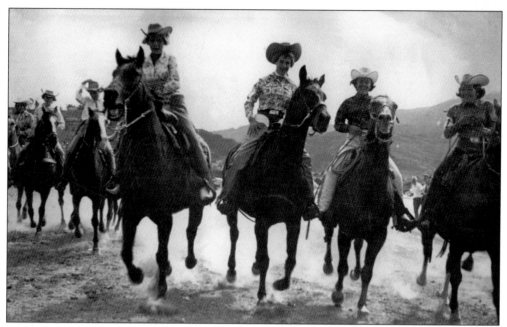

Pacifica used to have an annual rodeo complete with a parade and events showing off riding and roping skills. It has been held on the flats by the Rockaway quarry and in the back of the Linda Mar Valley where the Park Pacifica Stables are located.

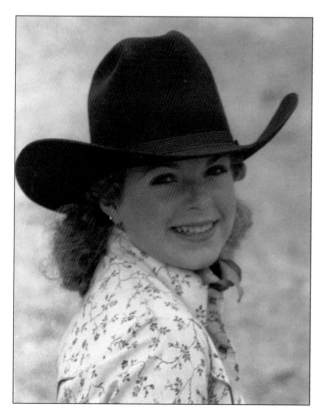

Vicki Robinson was a Rodeo Princess in 1981 and Rodeo Queen in 1983.

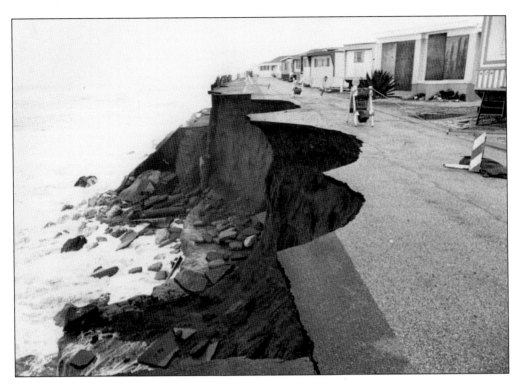

The shoreline of Pacifica has been moving eastward for centuries, but some years there is more movement than others. The winter storms of 1982–1983 undercut and washed away Fourth Avenue in the mobile home park. Huge boulders called "riprap" placed at the base of the bluffs at considerable expense serve to delay further erosion for awhile, but the force of really big waves is great enough to toss the boulders up and down the beach. The picture of the large wave swamping the street was taken toward the north end of Pacific Skies Mobile Home Park.

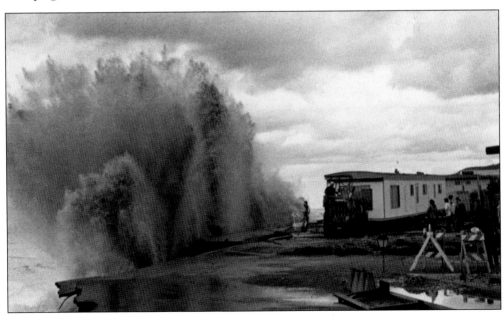

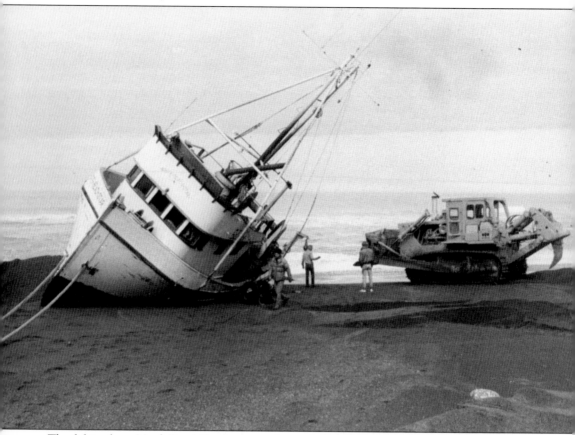

The fishing boat *North Beach Star* is pictured stranded on Pacific Manor Beach near the foot of Aura Vista Avenue in April 1984. She was one of 20 vessels known to have become shipwrecked on Pacifica shores. In nine cases, part or all of the vessel and its cargo were salvaged; the others were a total loss, sometimes with fatalities. Some of the more noteworthy wrecks were: *Beeswing*, schooner, February 1863, capsized then washed ashore at Mori Point; *Minnie G. Atkins*, schooner, June 1873, rammed by another ship; *Salinas*, steamship, December 1876, stranded on Point San Pedro with a load of peaches; *Bonita*, San Francisco pilot boat, July 1900, rammed by a whale; *Gifford*, four-masted barque, September 1903, carrying coal; *James 2*, four-masted schooner, August 2, 1910 (the anchor from this ship is mounted on a pedestal near the Pacifica pier); *Abraham Lincoln*, fishing ship, December 1931, galley exploded, off Rockaway Beach; *City of Sausalito*, December 1941, caught fire off Point San Pedro; and, of course, the *USS Johnson* mentioned opposite.

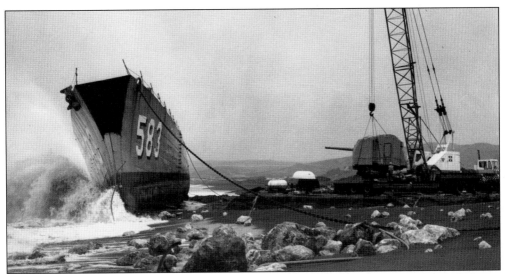

"The Day Our Ship Came In." In the fall of 1966, the *USS Johnson*, a Navy destroyer escort being towed south to be scrapped, broke its tow line in rough weather and beached just north of Mori Point. It became a tourist attraction as it was gradually dismantled over the next few months. Various folks who sought to establish salvage rights for themselves were disappointed. At one point, a demolition worker, overcome by his cutting torch fumes, had to be rescued by members of the fire department. In the end, the ship did become scrap, but not in the usual, more efficient manner.

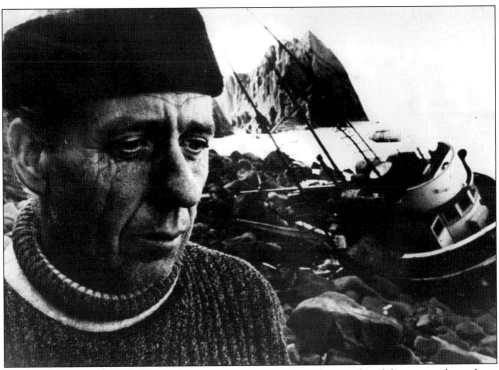

This award-winning *Pacifica Tribune* photo shows the sadness of a fisherman whose boat shipwrecked on Pedro Point.

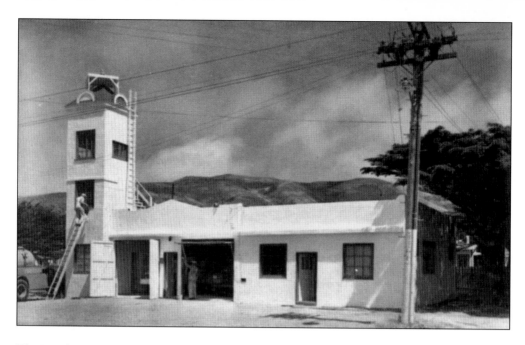

The North Coastside Fire Department station on Palmetto Avenue as it looked in the 1950s, served as a first aid station and center of enemy ship and aircraft lookout activity during World War II. Local citizens and Boy Scouts stood watches in the hose tower to raise the alarm if enemy forces came into view. They served in that capacity until the threat of attack by Japanese forces had subsided. The building also served as a community center in the 1940s and 1950s. The fire station was demolished after its equipment was moved to the new Linda Mar fire station in 1975.

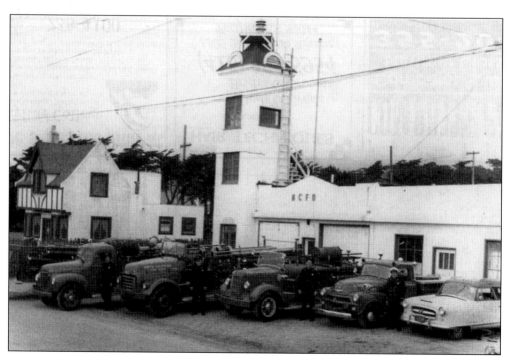

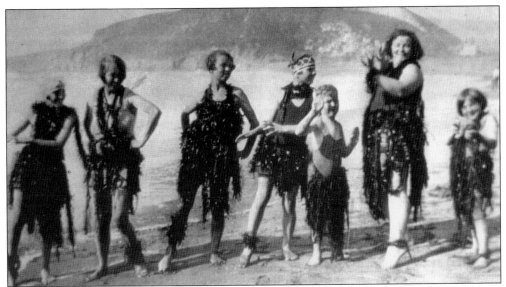

Seaweed dancing skirts? These light-hearted Rockaway "ocean sprites" show off their affinity with life on the seashore in the 1930s. This photo was taken by Laura Dunnigan, whose husband built the Snug Harbor tourist court and other Rockaway projects. Note the Rockaway Quarry in the back. People continue to be lured to the area because of the ocean.

Pictured are mayor Harland Minshew and activist Edna Laurel Calhan. Shortly after moving to Pacifica in 1949 she founded the Coastside Democratic Forum, now the Pacifica Coastside Democrats, the oldest political club in San Mateo County. Among her other creations was the Fifty Plus Club for senior citizens, and an annual competition for Christmas lighting. Calhan lived well into her 90s.

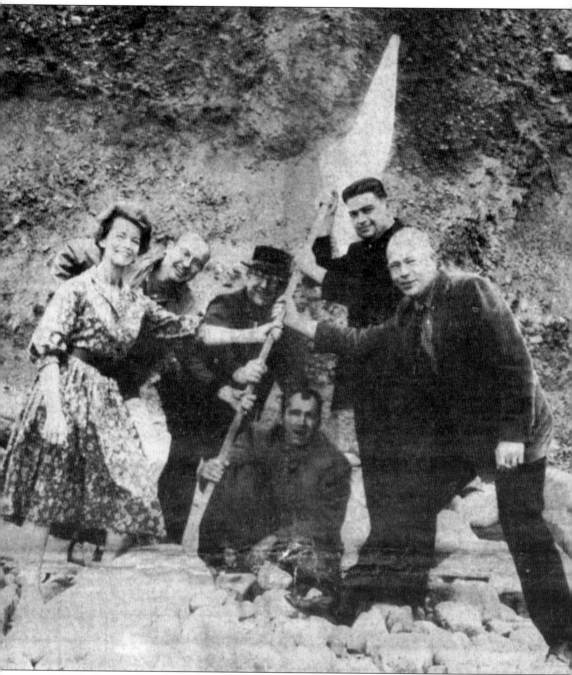

Published reports in 1964 said that the federal government had declared San Pedro rock, used as a landmark by Spanish sailors and a familiar shoreline fixture before and since, as surplus property. At first alarmed (and later amused), city council members agreed to pose for a *Tribune* photo, demonstrating their opposition. Pictured from left are Jean Fassler, city manager Karl Baldwin, Harold Feyge, Harland Minshew, George Mason, and Fred Ballew. The feds made an error, it was later disclosed.

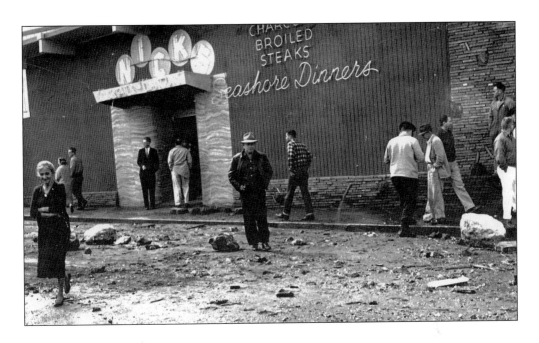

In 1958, storm damage to the Breakers Restaurant, below, was extremely severe. Across the street, Nick's Restaurant, above, fared better. The Best Western Lighthouse Hotel now occupies the Breakers site, and a strengthened sea wall helps protect it. Storms continue to do damage along the waterfront every few years though. At about sunup on February 22, 1998, a rogue wave smashed in the front doors of Nick's Restaurant and covered the eating and dancing areas with salt water. The family and employees quickly squeegeed out the free-standing water.

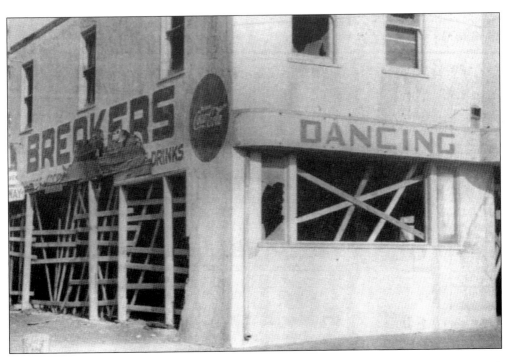

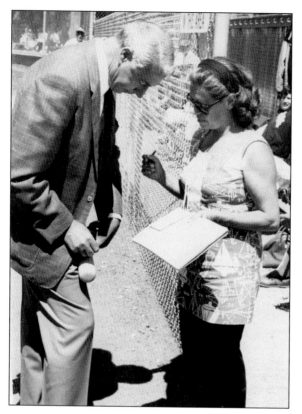

Joe DiMaggio autographs a bat for Mrs. Carl Vallero, wife of the team manager, on the occasion of the team sponsored by Lou's Phillips 66 (on the site where Denny's now sits—the family now operates the Texaco service station across Linda Mar Boulevard) winning the Joe DiMaggio League (16-to-18 year olds) state championship at Palo Alto on August 26, 1970. The under-rated team whipped Hollywood, Long Beach, Menlo Park, and San Francisco on their way to the crown. Among the many standouts were MVP Bill Downing who set a record for the number of hits (11) in a state DiMaggio tournament, and All-Tourney Selectees Mike Humphrey, Mike Rawlings, and pitcher Jim Emery who homered to help his own cause. Sponsor Lou Nannini was on hand along with over 200 Pacifica fans for the big win.

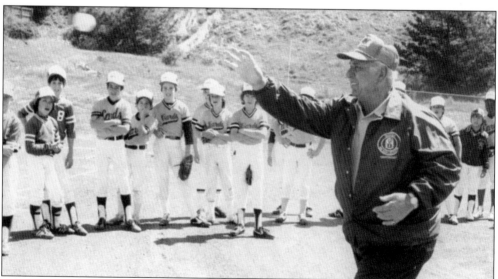

Parks, Beaches, and Recreation Commissioner Joe Grasso, better known as the "father of Little League in Pacifica," officially opened the 1982 Pacifica National Baseball season by tossing out the first ball. Sports activities for youth in Pacifica are numerous: football, baseball, softball, soccer, and swimming, not to mention the high school sports leagues.

Horacescope

Horace Hinshaw

In Pacifica, when the name "Horace Hinshaw" is mentioned, it's most often in connection with any of various kinds of community athletic activity. Hinshaw was the prime mover in formation of organized league soccer in Pacifica, co-founded and sustained the Pacifica Sports Hall of Fame which recognizes outstanding achievement, and, as sports editor of the *Pacifica Tribune* for 17 years, strengthened youth baseball and other programs for boys and girls and brought recognition to Pacifica as a strong sports town. He did this all while having a career with the U.S. Postal Service. As emcee of the annual Pacifica Fourth of July celebration, Hinshaw regularly dons striped pants and stove pipe hat and becomes the local version of Uncle Sam. If he's asked how he is, the answer is always, "Super!"

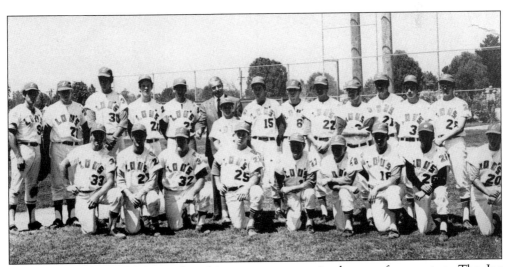

Baseball legend Joe DiMaggio lent his name to an entire league of youngsters: The Joe DiMaggio League. He visited Pacifica on occasion, and when the local Dave and Lou's service station team won the championship, he was right there in the lineup.

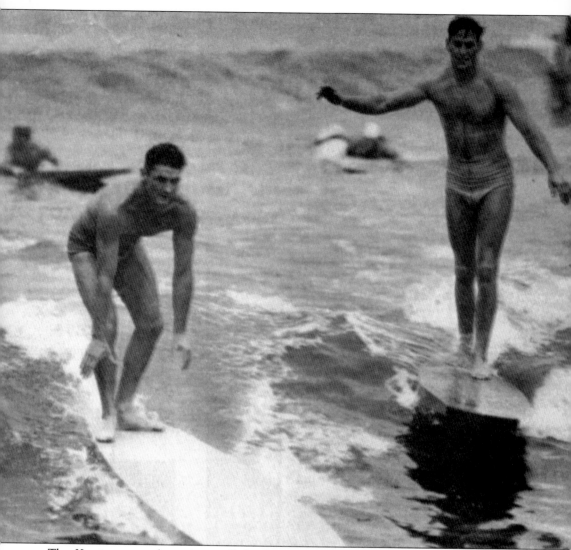

The Keatings started coming to Pedro Point in the 1930s. They loved water sports and recognized the area as a real treasure. There were Bob and Leah, and Bob's brother, Uncle Dick Keating—that's him on the left surfing with Tony Sanchez at Pedro Point around 1940. One of the oldest known sports (archaeologists have found evidence of Polynesians surfing over 3,000 years ago), surfing was introduced to California in 1907 at Redondo Beach by George Freeth. San Francisco's Ocean Beach is recorded as having been opened to surfing in 1949. By then, the sport had been practiced at Pedro Point for more than a decade.

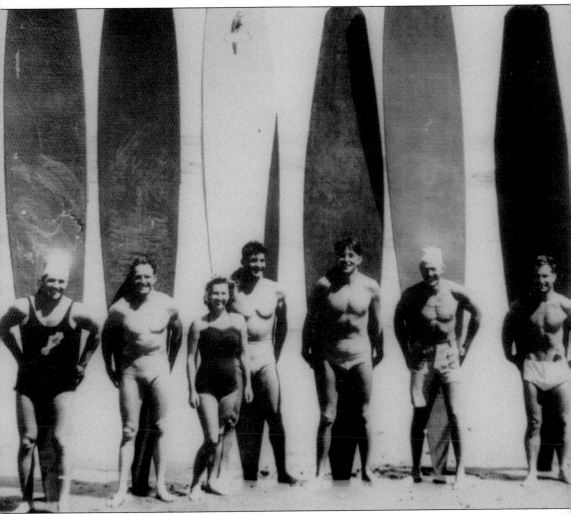

The boards were longer and much heavier in those days, and wet suits had yet to be developed. This group includes Leah Keating (third from the left), her brother Dick, Kenny Quinn, Felix Siedler, and Kent Frio. Early boards were of solid wood, and some of the longer ones, weighing over 150 pounds, had to be dragged to the water. Once hollow boards were developed, they were light enough to be carried and steered by dragging a foot through the water.

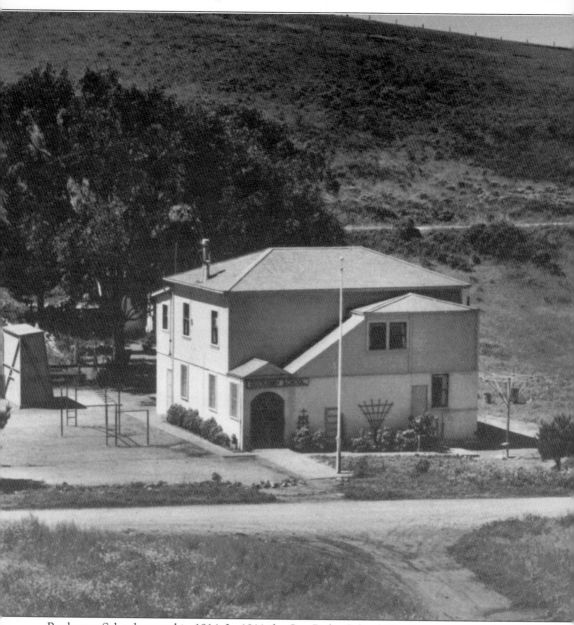

Rockaway School opened in 1914. In 1911 the San Pedro School District was separated into the Tobin and San Pedro School Districts. The Tobin District was located in the area from Vallemar south to Devil's Slide. The San Pedro School District included the area north of Vallemar to the Jefferson Elementary School District/Daly City boundaries. The district was named after the Tobins, the Hibernia Banking family who had investments in land in the San Pedro valley and the railroad. The two-story school was built in 1914, providing a classroom on each floor. In 1924 the name of the school and the district was changed to Rockaway. The school building is still standing and used as a private residence. Grace Adams, the legendary and much respected principal of Rockaway, became principal of the new Linda Mar School in 1956. She began her teaching career in 1915 in the crowded, tough neighborhoods of New York and left behind many stories of her skills as a teacher and disciplinarian.

Pacific Manor School opened in 1952 and closed in 1992. Pacific Manor was the coastside area where the first of the large housing developments occurred. There were plenty of children to fill the Pacific Manor School when it opened in 1952. The building was designed with the same finger plan as Sharp Park School. The school became the center of community activity. PTA meetings were filled to capacity. Most memorable of the many activities was the spring dance festival with the maypole. The school is now home to the Ocean Shore School magnet program.

Sharp Park School opened in 1950 and closed in 2000. The application for state funds to build the Sharp Park School was sent in before the San Pedro and Rockaway School Districts merged in 1949–50. The school's innovative finger-style design drew nationwide attention. The first phase was barely finished when Mrs. Drury, the principal/superintendent, was determined to move into the new school before summer break. It had been raining, which added problems for the students who had to carry their own supplies and books from the old school to the new through the deepening mud. Older children and teachers put down wooden planks or helped carry the younger ones. Mrs. Drury was especially proud of the new kindergarten room even though her office was in the broom closet. The school was designed for kindergarten through 8th grade. Later additions included completely outfitted cooking and shop facilities for 7th and 8th grades.

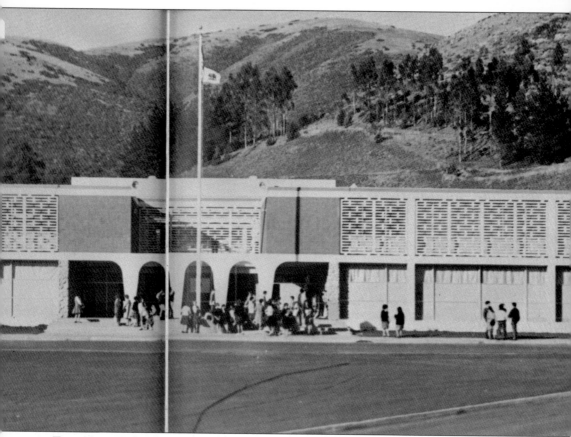

Terra Nova High School opened in 1961. The first principal was Harold Tonini. Connie Mason (Brown) was the first PTA president. James Cooper and Dr. Jerry C. Miles represented Pacifica on the Jefferson Union High School District Board of Trustees. The school was not finished before students began classes. Parent volunteers helped fill in where needed. PTA members under the chairmanship of Connie and June Alley opened a snack bar for students to use until the food service facilities would be finished. In the six weeks that they ran the snack bar they became the wealthiest PTA in the county. The money was used for much needed school projects, such as benches in the courtyard for students to sit on while eating. It was not easy to get to the school. There was a narrow road and an old rickety bridge over the creek. Both were soon replaced. A third story was added in 1963.

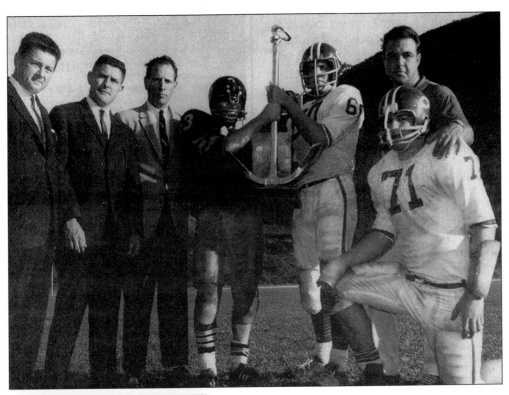

One of the early high school athletic competitions that brought Pacifica together was the annual "Anchor Game," a contest between the Terra Nova and Oceana varsity football teams. A large "anchor" trophy was the prize, proudly displayed in the lobby of the winning school. This 1967 photo shows the spirit of the event, which ceased to exist when Oceana High School eliminated its football program.

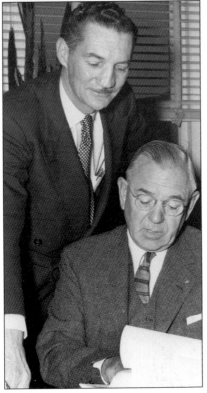

Fred Lucas, left, the first Laguna Salada Union School District Superintendent during the boom in school age population, confers with another longtime public official, Congressman J. Arthur Younger.

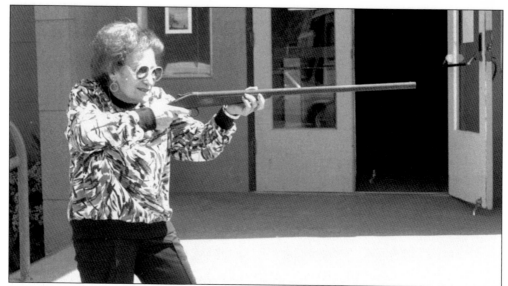

This shotgun, now the property of the Pacifica Historical Society, was held by Lydia Comerford Fahey when she kept the Ocean Shore railway surveyors from her property in 1905. After a satisfactory financial understanding, surveying proceeded. The weapon is being held here by Giulia Gervais, daughter of Italian immigrants. Mrs. Gervais was born in San Pedro Valley in 1912. Her family later leased land from Mrs. Fahey, whose seaside ranch was crossed by the railroad. Michael Comerford, a highly trained horticultural expert, arrived on the Coastside in 1853 from Great Britain via Australia. His granddaughter Lydia lost her husband to an early death. Then her 13-year-old son drowned. She and members of her family lived on the Coastside for a full century.

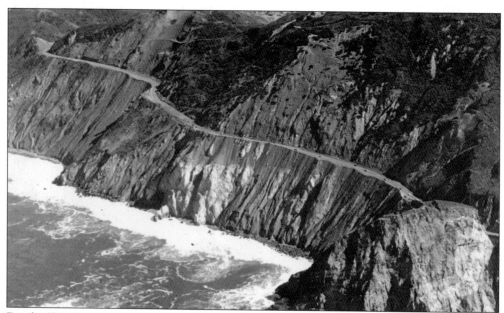

Devil's Slide has always been a bigger challenge to transportation than individuals. The Ocean Shore Railroad perched on the same ledge that later held Highway 1. The road today is slated for eventual closure, with a $230 million double-bore tunnel scheduled for eventual construction.

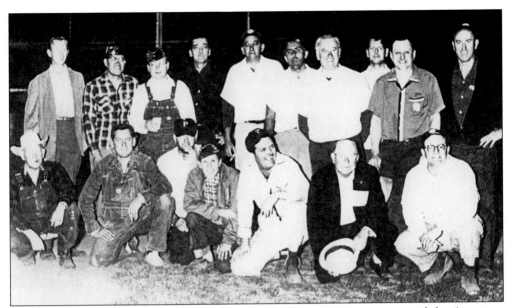

The score has been lost, but members of the Pacifica Tavern Owners team and the American Legion team posed happily together after a 1961 donkey baseball game. Pictured here from left to right are: (back row) Jerry Miles, unidentified, Gerry Schumacher, Jack the Barber, Skinner Girard, Nick Gust, Nat Corino, Don Wright, Joe Major, and Larry Kennedy; (front row) Russ Kelly, two unidentified, Lee Forster, Tom Hardwick, Al Sohl, and Fred Plate. The game was played at White Field on the Alma Heights Academy campus.

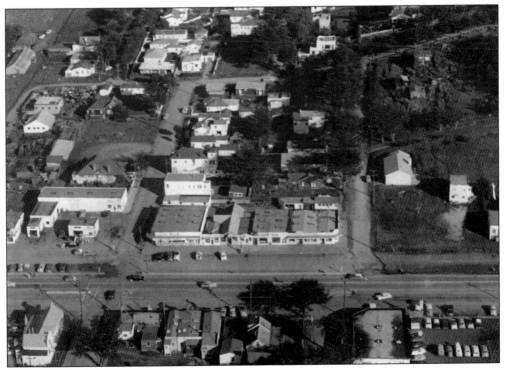

The Sharp Park district.

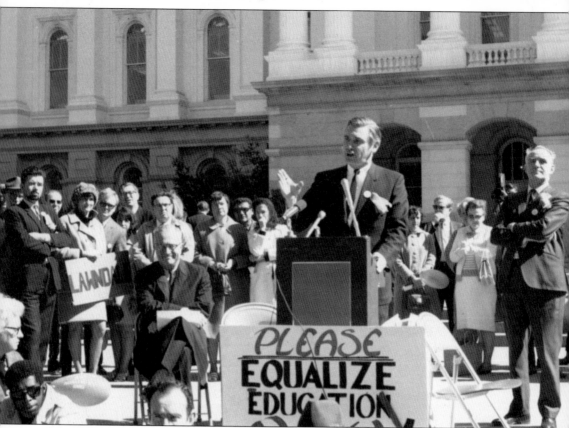

Hundreds of Pacificans descended on the state capitol in 1969 to lobby state legislators to "Equalize Education." Pacifica's Laguna Salada Union School district residents joined protesters from many other areas to ask the state to make adjustments so low-wealth districts would not be penalized because they lacked tax-producing industry and business in relation to other areas. The dilemma has plagued local school districts for decades and continues to be a problem. Assemblyman Leo Ryan addressed the "March to Sacramento" group.

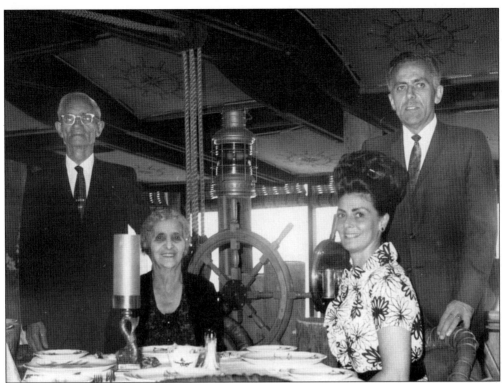

Few business families in Pacifica have had a greater impact on the history of the area than the Gusts. Pictured above are Charles and Anastasia Gust with son Nick and his wife Lorraine. In 2002, the Gusts celebrate 75 years of doing business on the Coastside. Charles Gust began selling sandwiches in Rockaway Beach in the 1920s and his son Nick eventually took over, expanding the "Rockaway Cafe" into Nick's and the Seabreeze Motel. (Nick also was a powerful political force, serving on the city council and being named mayor four times, which is still a record. He's at the far right in the lower photo.)

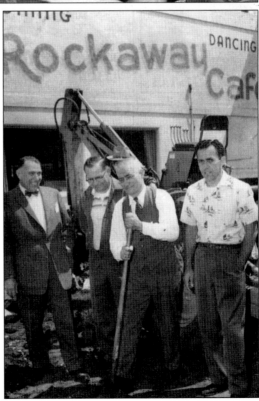

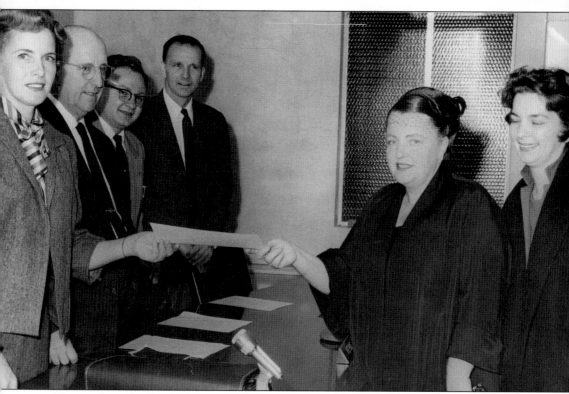

The words to "Hail Pacifica" were written by Mrs. Grace Ayres, shown receiving a copy of the resolution adopting it as the official song of Pacifica with Mizpah president Lida Shay (the words were first published in the Mizpah *Coastside Capers*) from council member Harold Feyge as mayor Jean Fassler and council members Gerry Schumacher and Don Miller look on. The words are sung to the tune of "Ta Ra Ra Boom De Ay:":

A city new has joined our state a city by the ocean side
Rising near the Golden Gate
Self reliant, unified
Room for growth and hope is here
Trees and grass and smog-free air
Future brave without a fear
Scenic views beyond compare
A Place for pleasure too is found
Our people built a city fine
Golfers, archers all abound
Using dreams of yours and mine
Churches raise their spires so tall
Held fast to our sturdy past
Beckoning to one and all.
Built a city that will last.
chorus: We hail Pacifica, our own Pacifica
Sea winds ever blow, our cheeks are all aglow
We love your sandy shore
Our home forevermore
Our own Pacifica, all hail Pacifica

The old wastewater treatment plant on the Sharp Park shore was also designed to house the city council chambers. The pier was actually built to carry the plant's outfall line, dumping treated wastewater at sea. The handsome Spanish-style architecture belies the mundane function of sewage treatment and is more appropriate to the functions of city government. It has been decommissioned and a new sewage plant has been built in the quarry area. Final disposition of the Sharp Park plant is still unknown. The city would like to have a hotel built there and has entered into contract with a developer.

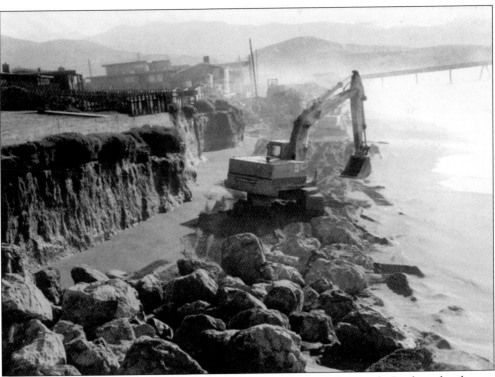

Pacifica's coastline has needed "armoring" in places, especially Beach Boulevard, where a seawall and "riprap" helps prevent the inevitable erosion.

The storms of the winter of 1962 severely flooded the western section of Linda Mar, site of the former Lake Mathilda. Surfboards provided mobility during the soggy interval, and a former Marine amphibious truck (called a "duck" because of its military designation DUKW—"D" for 1942, "U" for utility, "K" for front-wheel drive, "W" for rear-wheel drive) helped get many stranded drivers to dry ground. The Rotary Club of Pacifica, founded just the day before the big flood, turned out in force to join the rescuers—their first community action project. Incidentally, Bob Fizer started the effort to charter the Rotary Club of Pacifica; then city manager Karl Baldwin and *Pacifica Tribune* publisher Bill Drake were among the founders although Bill did not become a regular member because the others chose Tuesday, the newspaper's deadline day, to hold the meetings. Oops!

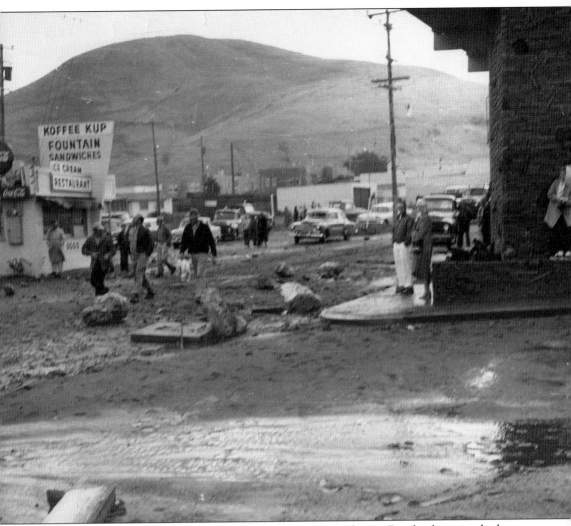

Pacifica has been plagued with storms through the years. Rockaway Beach often gets the brunt of wet weather, as in this photo, but the hills are also threatened with landslides while the valleys are concerned about flooding. Tragedies of national scope have occurred in Pacifica because of storms and the city has worked hard to improve geological surveys to address landslides and control flooding through a massive project at San Pedro Creek. But no matter what precautions are taken, severe storms can still bring tough times to the coast.

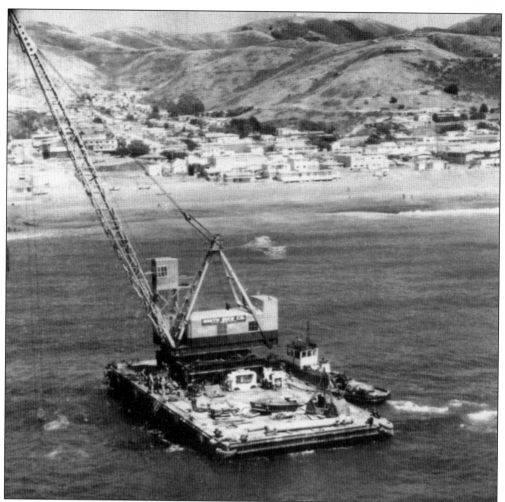

The waters off Sharp Park are often turbulent; the level of sand on the beach varies by up to ten feet as shifting wind and wave action moves huge volumes of sand back and forth along the strand. So it was no easy task to construct the Pacifica pier. The project was paid for partly by the state of California because it supports a pipeline that formerly served as the outfall for the old wastewater treatment plant, and partly by the federal government because it is a fishing facility open to all. A "spider," or moveable construction platform, facilitated the difficult task. The surf constantly wears away the surfaces of the pilings and the bulkhead at the shore end of the pier, with the result that expensive repairs are needed on a regular basis. Now that the pipeline is no longer used for wastewater disposal, state funding has ceased, putting the long term existence of the pier in doubt.

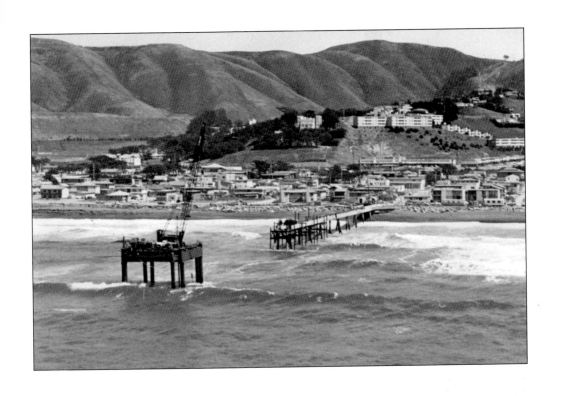

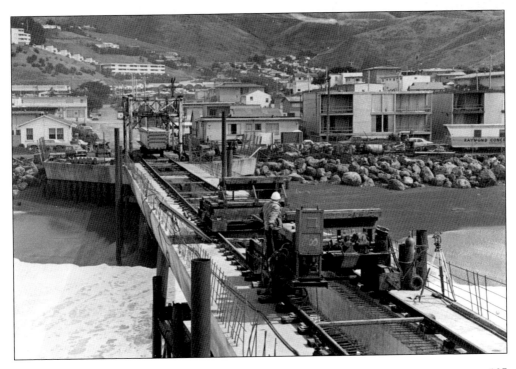

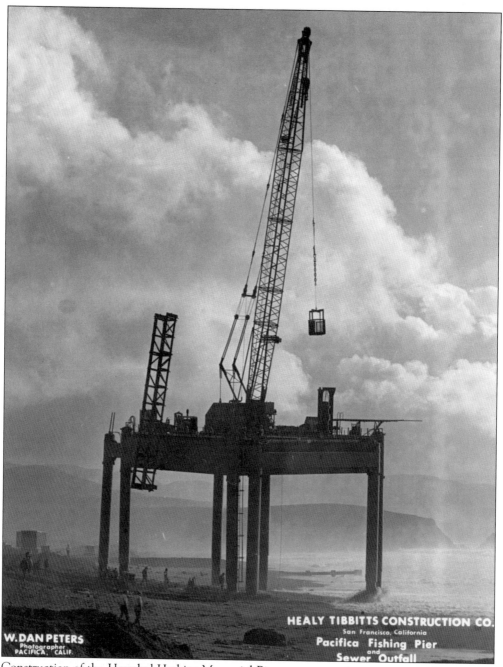

Construction of the Herschel Harkins Memorial Pier was an amazing engineering feat.

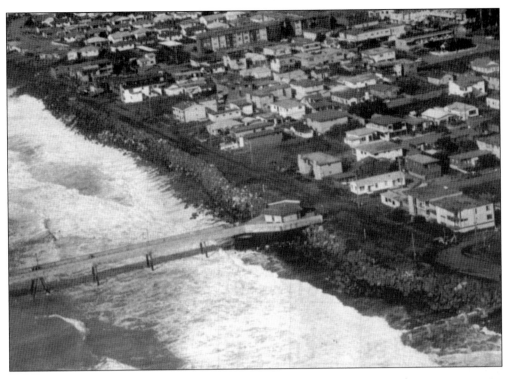

The Pacifica pier has become a destination fishing location, particularly during salmon season. The future of the pier is in jeopardy, however.

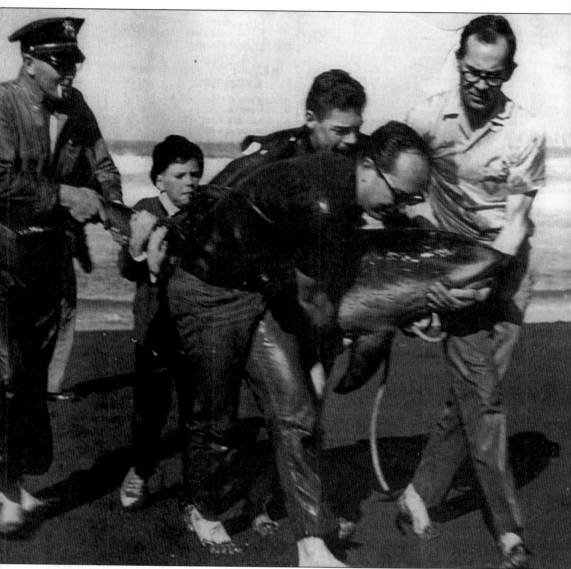

Pacificans have an affinity for sea creatures. Volunteers worked long hours to save as many as possible of the sea birds coated with oil from the spill of 1971. Bill Hammer donated bags of material for the volunteers to use cleaning oil off birds. It is a difficult and heart-rending task as most of the affected birds die from contact with oil slicks. The Marine Mammal Center, headquartered in Marin, has an excellent record of saving distressed porpoises, seals, and sea lions. The picture of the group carrying a porpoise off the beach was taken in 1965, but similar rescues take place here frequently. Effective rescue is not a simple task; those who do come across distressed mammals on the beach should immediately contact the Marine Mammal Center rather than trying to proceed on their own.

Women, from the town's beginning, have played key roles in Pacifica's governing process. This was never more so than in 1992 when the final election results were announced to a slightly stunned but amused electorate. Pictured, from left, are Barbara Carr, Vi Gotelli, Bonnie Wells, Julie Lancelle, and Ellen Castelli. Wells was the only sitting council member not recalled in a contentious battle over the previous council's decision to impose a "Lighting and Landscaping District" tax. The other women members were chosen over several male candidates. The all-women council received national attention in newspapers, television, and magazines where it was noted the "Fabulous Five" may have been the first of its kind, anywhere. Consensus: they did a pretty good job.

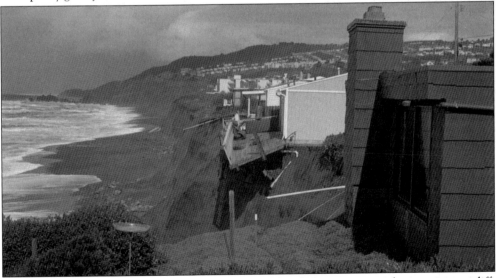

In 1998, the terrific wind, waves, and rain generated by El Niño storms sped up erosion on cliffs along Esplanade Way. A dozen homes were threatened as the bluffs beneath them gave way. Pacifica became the poster child for the wild California storms that year, as photos of houses clinging to the cliffs were seen around the world. Eventually, the city had to demolish all but the two northernmost homes on the block, creating an oceanfront view for the existing homes across the street.

A group of city council members and former members watch and smile as mayor Pete Murray cuts the big cake at a celebration of the City of Pacifica's 25th anniversary on November 24, 1982. Pictured, from left, are council members-elect Charles Curry, Jeanette Warden, and Peter Loeb with council members Ginny Jaquith, Don Halverson, Dan Modena, Don McMannis, Fred Ballew, Grace McCarthy, and Fred Howard.

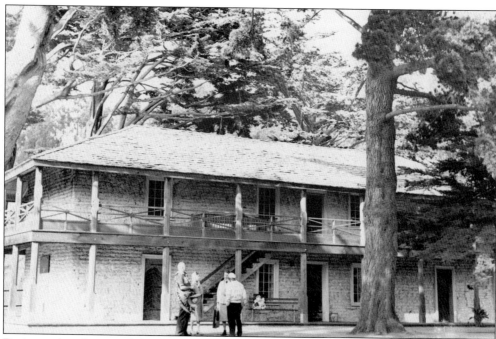

Designated a historical landmark and restored by the San Mateo County Historical Association, the Sanchez Adobe remains an abiding symbol of the California lifestyle of almost two centuries ago. A depression in the U.S. caused a migration to California in the late 1830s, and by 1846, 700 Americans lived in California. On January 24, 1846, John C. Fremont stayed overnight with Francisco Sanchez at the adobe on his way to Monterey. The California Republic, or "Bear Flag" Republic, was proclaimed on June 6, 1846, and Fremont took control in Sonoma. After a somewhat chaotic period, the U.S. flag was raised at Monterey on July 7, 1846, and the Bear Flag Republic ended its brief existence. A U.S. Land Commission was formed to sort out land claims. Sanchez filed his claim with the commission September 22, 1852 and had his claim confirmed, or "proved," by the commission December 13, 1853.

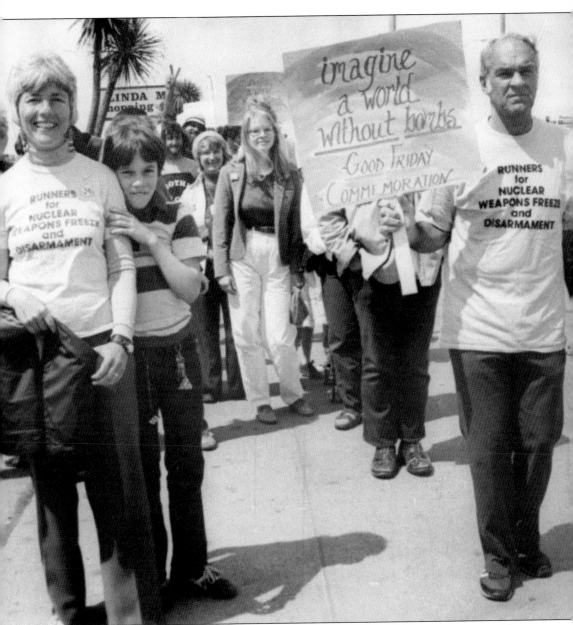

Heading a group of 50 in a march to "raise consciousness" about the nuclear war threat is Diane Evans (Pacifica nurse and housewife), her son Blair, and husband Bill. The Evans family has been selling nuclear "freeze" T-shirts and collecting signatures for the freeze initiative for the state ballot. The demonstrators walked the length of Linda Mar Boulevard Friday afternoon to publicize the growing peace movement. The photograph was by Beverly Ramsay for the April 14, 1982, *Pacifica Tribune*.

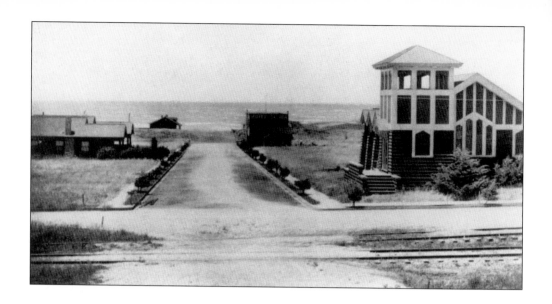

This early photo of the Little Brown Church shows it starkly alone in Salada Beach. It was one of three structures built on the Coastside by the Presbyterian Church. Completed in 1910, it served as Salada Beach's (and later, Sharp Park's) only church for most of its existence. In 1920, 23 members welcomed the addition of electric lights with a celebratory meal. The building served as the city's police station since the early 1980s. Its future is uncertain but the Pacifica Historical Society is working to save it. For more info contact the Society at P.O. Box 752, Pacifica, California 94044.

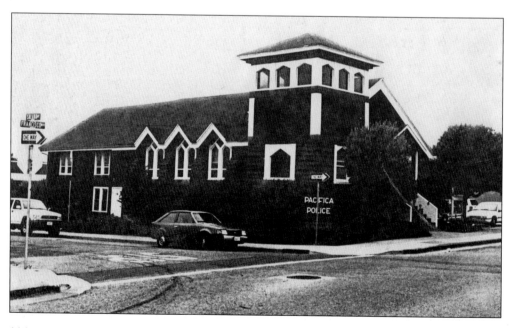

The bride and groom, Mr. and Mrs. Mason Brown, have ample reason to put their hearts into the "Save the Little Brown Church" effort. They were married there September 17, 1977. Rev. Cliff Alsen presided and the best man was Tom Hlvenka. Hundreds of couples were married in the church since it was built in 1910.

Pacificans have a way of making fun out of work. Back in the 1970s, Hilda Plate of the Linda Mar School PTA organized a "pie fight" fundraiser. Many good-natured parents joined in the high jinks until Sheila Hyman and Zelda Thompson somehow managed to win the day, or at least appeared to be the last ones standing. After the fun was over, their husbands wouldn't let them in the house until they were hosed down in the middle of the street, to the vast enjoyment of the neighbors.

One of the most active youth activities in Pacifica for many years has been 4-H. The organization began as "children's corn clubs" as a way of demonstrating the superiority of improved corn varieties to farmers who had resisted trying the new-fangled seed. Nowadays, 4-H activities include growing crops, raising livestock or poultry, raising puppies destined to become guide dogs, photography, and computer skills. A "project" is composed of five youngsters with an adult advisor who select an activity for a year and are judged on their success at the end of that year. Former local member Mike Azevedo won a trip to Chicago in 1980 for the excellence of his forestry project. Pacifica 4-H formerly had a farm on Perez Drive, but it has since been sold. They are establishing a new site on the grounds of Linda Mar School.

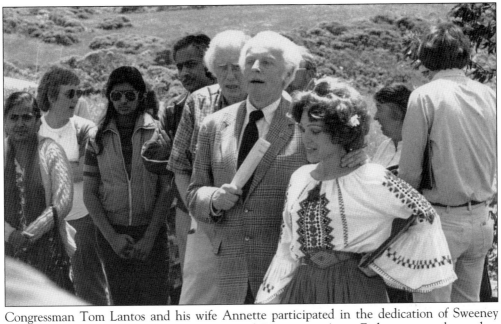

Congressman Tom Lantos and his wife Annette participated in the dedication of Sweeney Ridge as a part of the Golden Gate National Recreation Area. Eighteen years later, they attended the dedication of Mori Point into the National Park system as well. Lantos was instrumental at the federal level for the success of both projects.

Nick Gust was mayor four times and Grace McCarthy held that title three times.

The Miss Pacifica pageant was held before incorporation as a way to raise funds needed for the new city. The event continued to be a popular contest for many years, but eventually fizzled out.

Tom Jackson enjoys playing the part of a knight in a Medieval Festival that was a later manifestation of community spirit.

Christ the Good Shepherd guards his flock. This 12-foot bronze statue stands tall above Cabrillo Highway, dwarfing 5-foot sculptor Stella Pilgrim. She was inspired by the faith of Rev. W. Adalbert Gluszek, a Polish priest who survived WWII German concentration camps to spend much of his century of life in Pacifica.

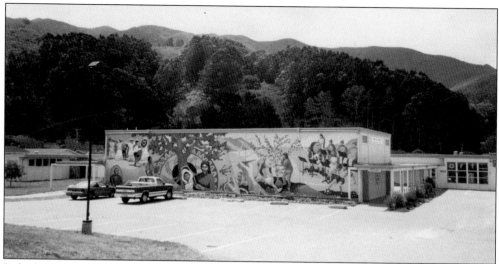

It looked as if Sanchez School didn't have much of a future once the declining student population caused consolidation of classes into other schools. But then a coalition of local artists and performers set about to turn the facility into the Sanchez Art and Performance Center. Marshalling crews of volunteers, they cleaned up the classrooms, turning them into galleries and artists' studios, and converted the multi-purpose room into a performance facility with a stage, adjoining kitchen, donated chairs and large, colorful abstract hangings to lend visual interest and improve the acoustics. Artist Andrew Leone designed the mural seen in this photograph and supervised its execution by other crews of volunteers. Mildred Owen guided the organization, now called Pacifica Performances, that brings the great variety and quality of musical performers to Pacifica. Mayor Dorothy Edminster dedicated the facility, which belongs to the City of Pacifica, on August 30, 1998.

The Pacifica Community Center at Crespi Drive and Highway 1 was originally a telephone company switching station that was transformed into an important municipal building.

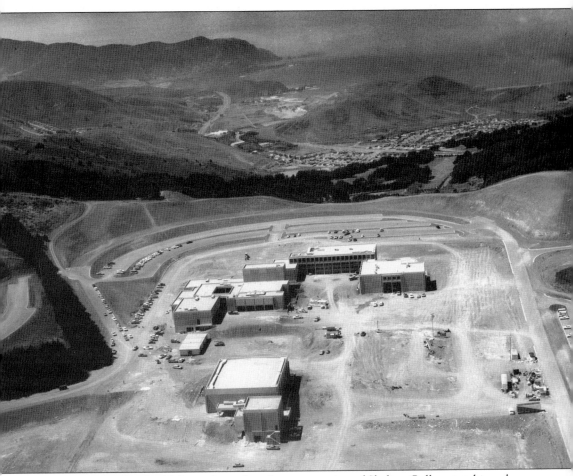

It appears in this *Pacifica Tribune* photo that the construction of Skyline College is taking place in Pacifica in 1968. Actually, the college campus overlooks Pacifica from miles away at the top of Sharp Park Road at the edge of San Bruno. It is for all practical purposes a hometown college for Pacifica, and a big percentage of the students are Pacificans. An early search for an appropriate site in Pacifica proved unsuccessful.

The Pacific Coast Fog Fest began, as do most community festivals, as a way to bring attention and revenue to the city. For 16 years, the event has dominated Palmetto Avenue the final weekend in September. The date was chosen because that's generally when Pacifica enjoys its best weather and the notorious fog is banished. A Fun Fest, which actually predates the Fog Fest, takes place on the same weekend, with non-competitive games and activities. Dr. Bill Michaelis, below, internationally famous for his activities in the recreation field, coordinates the Fun Fest event.

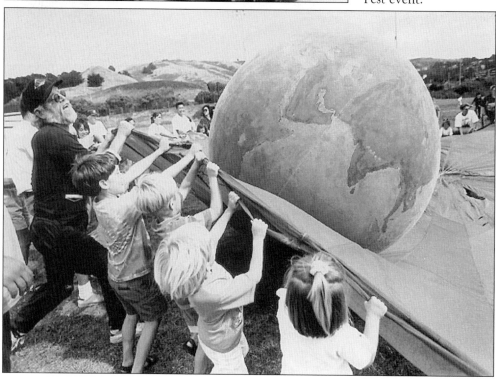

Six

PACIFICA FROM THE AIR:
DRAMATIC AND HISTORICAL VIEWS

This aerial view of central Sharp Park shows the layout of Oceana High School which was dedicated on November 11, 1962. It had been scheduled to open before Terra Nova, but was delayed until the new highway plans were confirmed. Under the guidance of architect Mario Ciampi the school was custom built to conform to the hillside. It was painted a bright red and blue, with diagonal stripes on the raised portion of the gymnasium roof. There was no senior class the first year. The students from Pacifica had been given the option of remaining and graduating with the

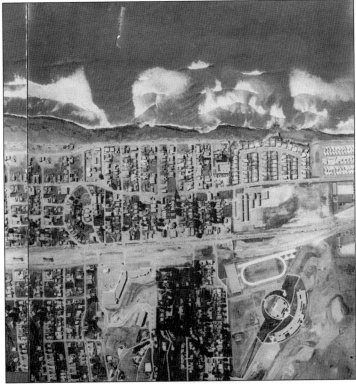

school where they had spent most of their high school years. The first principal was Ernie Ribera, and Grace McCarthy was the first PTA president. The Coastside residents found it hard to believe that after working for so many years to get a high school for this area they ended up with two high schools in less than a year.

Mori Point, now part of the Golden Gate National Recreation Area.

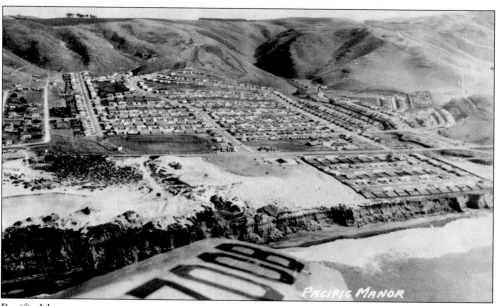

Pacific Manor.

124

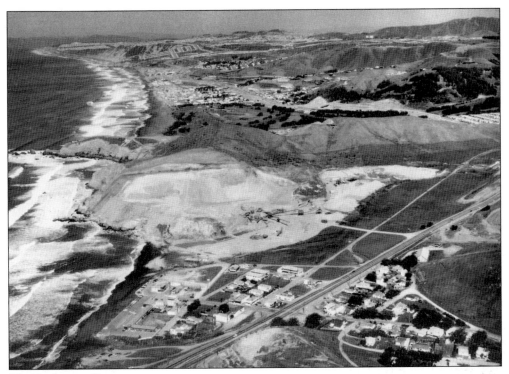

The Rockaway Quarry.

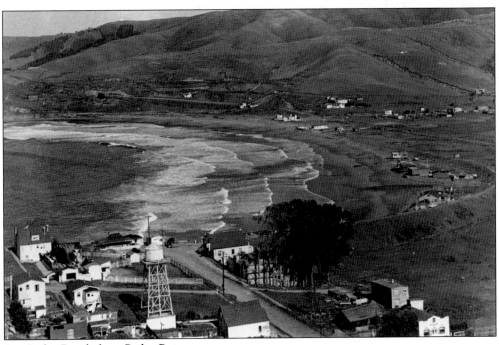

San Pedro Beach from Pedro Point.

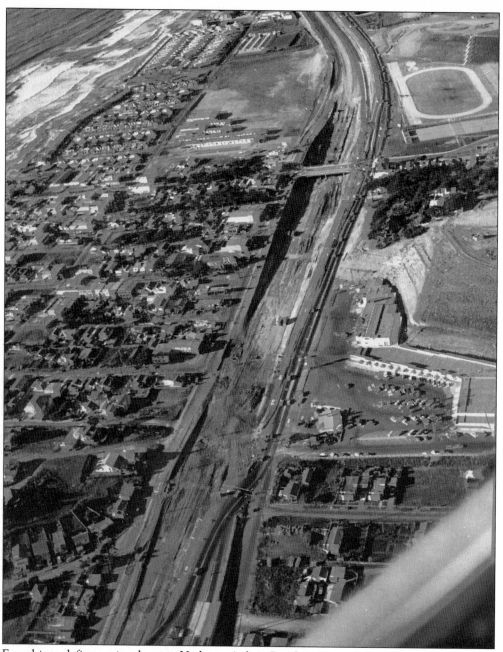

Few things define a city the way Highway 1 does Pacifica. Here is the massive cut that dug through the middle of town at Paloma Avenue in Sharp Park, forever changing the city. You can see the Oceana High School track in the top right.

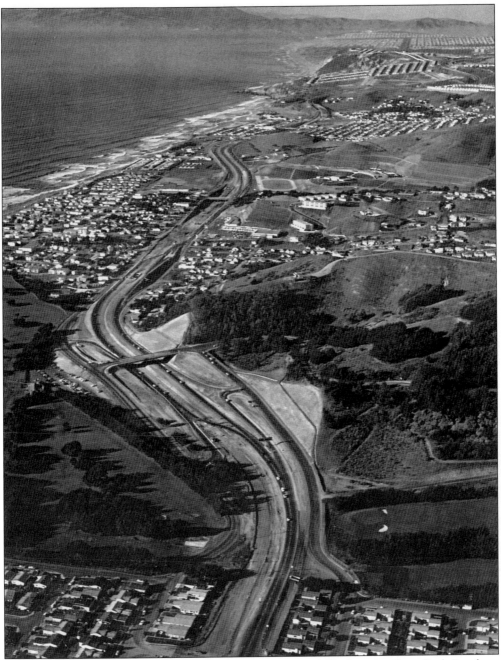

Highway 1 created enormous change to the sleepy town of Pacifica. At Sharp Park Road, an overpass led travelers directly into the Sharp Park Golf Course, owned by San Francisco. For years, Sharp Park Road was a treacherous, two-lane path. In August 1990, a four-lane, divided roadway opened, eliminating much of the danger and making Sharp Park Road a busy exit/entrance for the city.

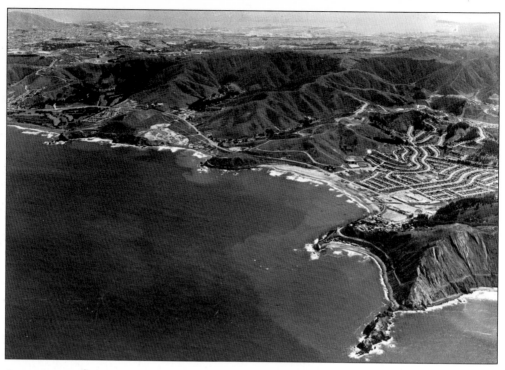

Scenic Pacifica is still a jewel in the San Francisco Bay Area.

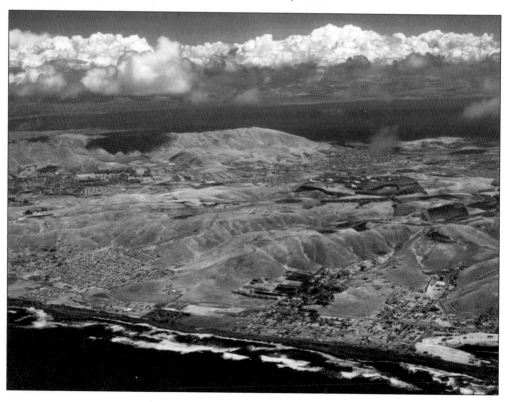